How to
PHOTOGRAPH
YOUR BABY

getting closer with your camera and your heart

nick kelsh

Stewart, Tabori & Chang
New York

Published in 2009 by Stewart, Tabori & Chang
An imprint of Harry N. Abrams, Inc.

Library of Congress Cataloging-in-Publication Data:

Kelsh, Nick.
 How to photograph your baby : getting closer with
your camera and your heart / Nick Kelsh. – 2nd ed.
 p. cm.
ISBN 978-1-58479-749-4
 1. Photography of infants. I. Title.
TR681.I6K44 2009
 778.9'25 – dc22

 2008033393

Editors: Elizabeth Viscott Sullivan and Tricia Levi
Designer: Karen Engelman of Luminary Books and Design
Production Manager: Tina Cameron

The text of this book was composed in Copperplate
and Garamond Condensed.

Printed and bound in China
10 9 8 7 6 5 4 3 2 1

HNA ▪▪▪▪▪
harry n. abrams, inc.
a subsidiary of La Martinière Groupe
115 West 18th Street
New York, NY 10011
www.hnabooks.com

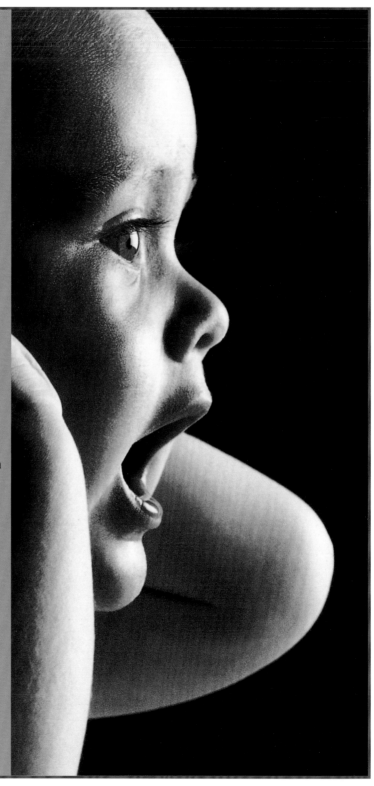

In the ten years since the first edition of *How to Photograph Your Baby* was published, I have received hundreds of e-mails and letters from readers saying the simple approach in this book has made a huge difference in the way they take pictures. At least a dozen of them photographed their own babies . . . and then the babies of their neighbors and friends. They wrote to say they had started small businesses photographing children and were having the time of their lives.

Maybe that's you.

This book is for people who want to create stunning photographs of the babies they love with a minimum of effort and fancy equipment (a point-and-shoot camera will do).

I'm going to assume that most of you who are reading this book are parents, although I know that there are lots of grandparents, aunts, uncles, and friends who love certain children as much as any father and mother, and who will want to take beautiful pictures, too. Except for an optional

section, "A Little Advanced," there will be no technical photographic discussions included in this book. I'm sensitive to the fact that new parents are likely overwhelmed by dozens of other child-rearing details and are probably sleep deprived.

I can't imagine that you want to digest the relationship between flash ratio and ISO. For that reason, this is the last sentence in the book that will contain the terms "f-stop" and "shutter speed."

Nor is this a book of general photography lessons. If you want to learn how to shoot better pictures on your vacation or capture that peak moment of action as your daughter scores a goal, you've come to the wrong place. What I provide in the pages that

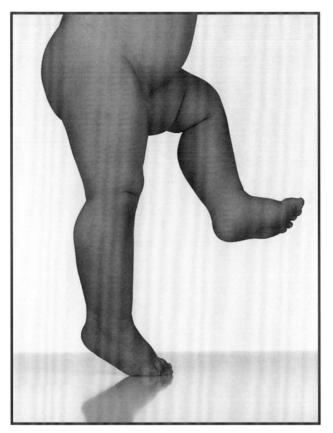

follow is a recipe for making beautiful baby photographs—that's it. Together we will try to record those incredible sights you see when you are alone with your baby. I am not going to turn you into a photographer, but I am going to hold your hand as you walk through one of the classic rites of parenthood—the photographing of the baby. If you follow the simple instructions in this book, your relationship with photography will be permanently changed.

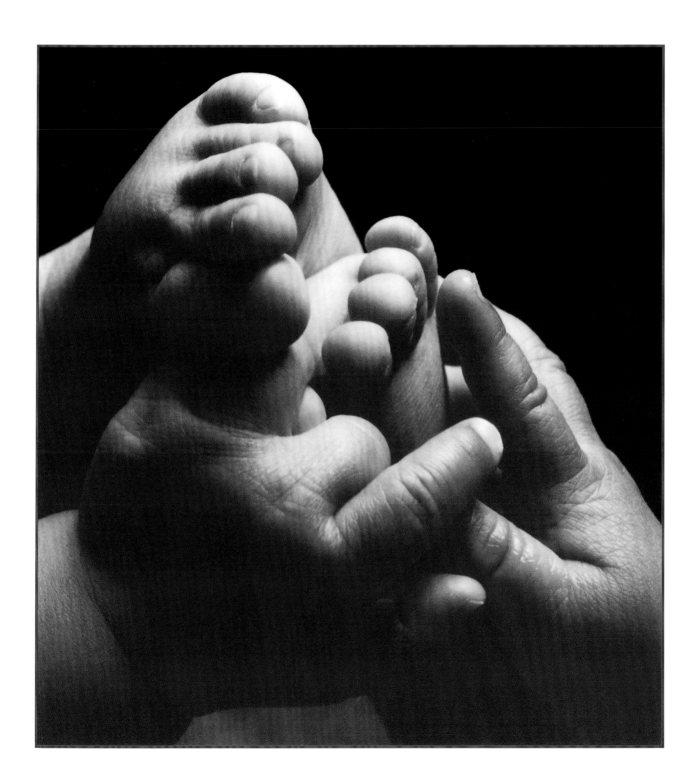

A NEW APPROACH

If you are an inexperienced photographer, two approaches to producing baby photographs are within your technical grasp. One is the traditional snapshot and the other is a basic photo session.

Snapshots are what most parents shoot all the time. Here's the course of events: their baby does something precocious or looks especially angelic, so parents fumble for the camera, point it, look for the shutter button, push the button, the flash goes off, and boom—snapshot. All this happens with very little consideration for aesthetics. This method is simple and limited and, in its own way, amazing. These modest photographs are among the first things people grab on their way out of burning buildings. The pictures produced by this method, however, generally leave the photographers feeling a little empty; they can't verbalize why, but their pictures just never look as good as what they saw in the viewfinder. (This has a lot to do with lighting and the flash, to be specific, but there's more on this in the "Turn Off That Flash" foldout.)

The subject matter in these pictures, however, and the love the photographers have for the subject—the most glorious child they've ever seen—carries the day.

Snapshots are priceless. I have drawers full of snapshots and I love them. But this book is not about snapshots. Most people have never considered another approach beyond snapshots. They assume that any greater photographic skill would require mastery over the mysteries of photography. Not true.

THE BASIC PHOTO SESSION

This is the approach I focus on in this book and it's one any amateur photographer can easily handle. For the purposes of this book, my definition of a photo session is putting the baby in beautiful light—near a large window or door to the outside—turning off your flash, and shooting more pictures than you have ever shot at one time, probably a hundred pictures in thirty minutes. The goal is to produce a few classic images that you and your baby will treasure forever. I know this works. I have watched some of my friends who are least competent with a camera make photographs that I would be proud to claim as my own.

There used to be a risk factor with the photo session. The cost of film and processing was intimidating. I think hesitation was beat into amateurs by watching their amateur parents shoot film. Every image was precious. (My younger sister actually

aged three years on one roll of my mother's film.) Now, with the digital revolution, you can push the button with abandon. I've had people tell me that the whole experience of taking tons of pictures was liberating, fun, and saved them several thousand dollars in psychotherapy bills.

Good photography requires thought, but I am going to try to keep the thinking required by you to a minimum. To accommodate the schedules of the parents of newborns, this entire book can be read in one short sitting. If you plan your photo session carefully—that is, when you and your baby are both rested, no one is hungry, and you're home alone—you are going to have a very gratifying experience. For one thing, people will comment on your surprising photographic skills. Beyond that, however, you will produce works of art that are visual statements of the feelings you have for this little person.

All you need is a point-and-shoot camera, a window or a door, a simple background, and of course, the baby you love.

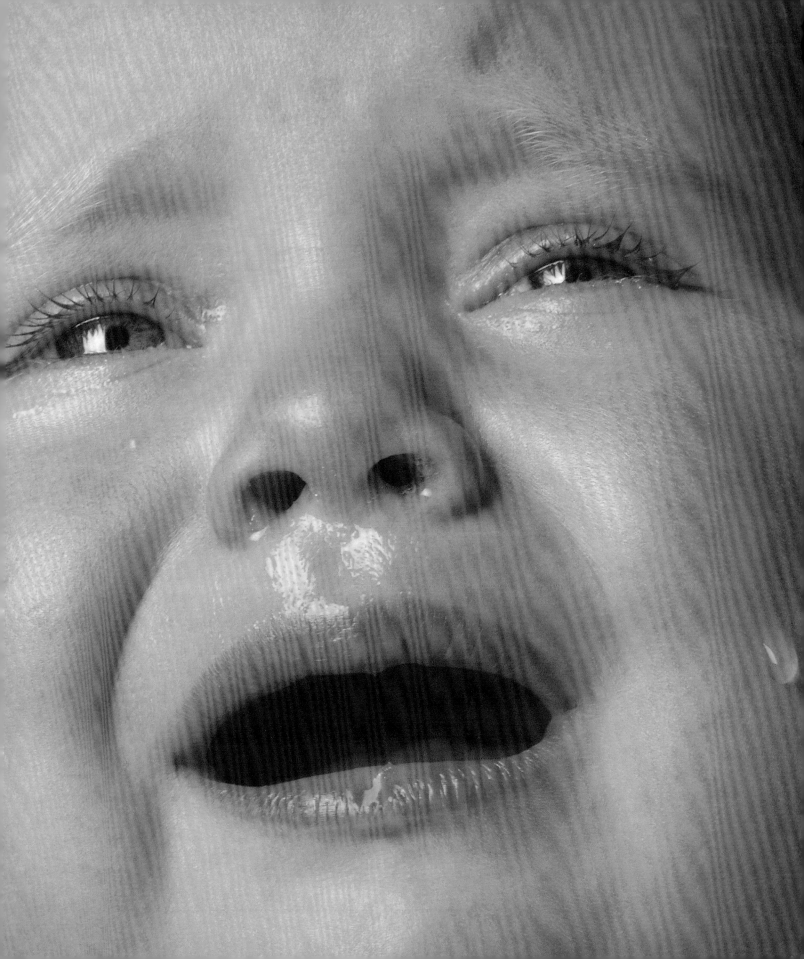

ON A PERSONAL NOTE

It strikes me as a little odd that I've written a book teaching people how to photograph their babies. Although Anna Quindlen and I coauthored *Naked Babies*, a book of essays and photographs celebrating the glory of babyhood, I've certainly never considered myself a baby photographer, let alone qualified to write a book about helping other people photograph their babies. And though it's true that I've been shooting photographs for almost thirty years and have certainly answered my fair share of questions from amateur photographers, I've never considered myself to be a photographic educator.

But I'm probably as qualified as anyone can be. My credentials have nothing to do with what kind of equipment I own or how many photographs I've had published in books or magazines. The expertise I have for this subject I share with every parent who has ever bought a camera, hoping to document the life of a new baby.

All any of us wants to do is create a memento of what our children look like at a given point in time. And if we follow our hearts, I believe we can elevate our snapshots to the level not just of family treasures, but also of family art.

When *Naked Babies* was published, a lot of people asked me the same question: Why did you choose to do a book about babies? After all, my only child was already eight years old at the time. Diapers and drooling were way behind us, so why did I wait so long to do a book about infants? When the answer came to me, it seemed so obvious: I missed my baby. There are only a few absolute statements that can be made about babies and one of them, regrettably, is this—one day your baby, too, will grow up.

Photography is a miraculous thing. No painter can hope to compete with the lens in capturing natural beauty, and enabling us to witness history and view the solar system. I used to stand transfixed as I watched an image appear through the murkiness of my darkroom. Now the instantaneous appearance of a beautiful face on the back of a digital camera is no less thrilling. And although the combination of this wonderful medium and a naked baby is almost overwhelming, a photograph of Abraham Lincoln is always going to be more important than a picture of a toothless infant. But I still believe that the most precious photographs in the world are in the wallets and purses of parents.

I wish you the most loving photo session with your baby. I'm sure you will amaze yourself with the results and create something your baby's babies will treasure forever.

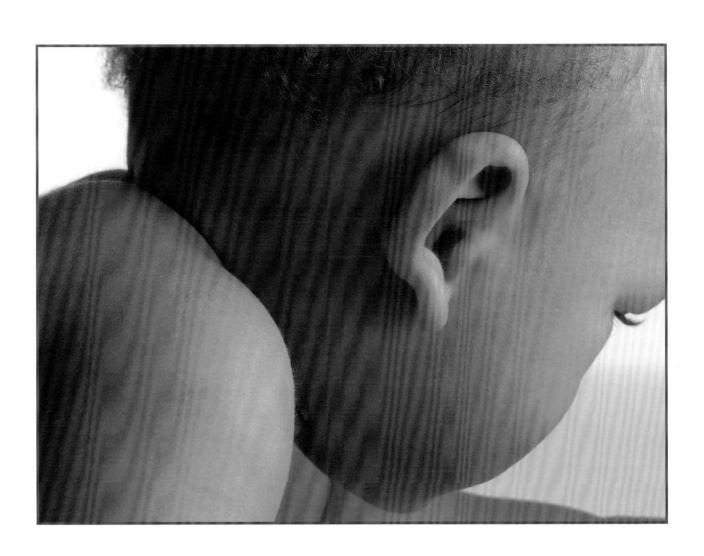

Contents

There are three basic ways to improve photographs that are described in this book—getting closer, shooting more pictures, and finding the right light. Of these, getting closer is the most important. Amateur photographers almost always stand too far away from the people they're photographing—often 10 to 20 feet from their subjects. And when people are teeny-tiny this is an even bigger problem, because a baby from 10 feet away looks a lot smaller than a linebacker in your viewfinder.

Get close. Then get closer. It's that simple. I'm talking 2 or 3 or 4 feet here. It's even okay to crop off the top of your baby's head. You need to get as close as your camera will focus (an explanation follows in the "Focusing Close Up" section of this foldout).

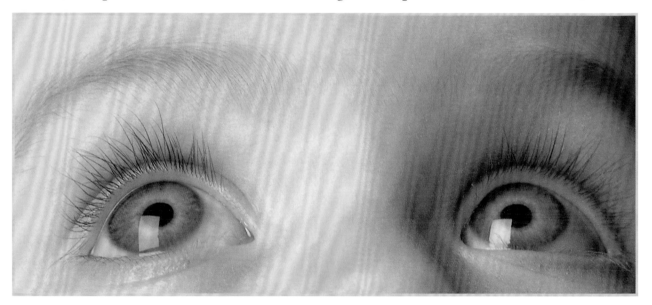

Because amateurs often stand so far away from the babies they are photographing, the babies get completely lost in the picture. They may be trying to get decent photos of their baby, but actually they're doing a marvelous job of documenting their living room. If you want a picture of your living room, fill the viewfinder with living room. If you want a great baby picture, fill the viewfinder with baby. Think of the photographic close-up as a visual declaration of what's in your heart.

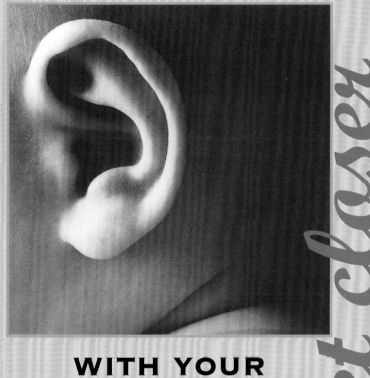

WITH YOUR

CAMERA

AND

YOUR HEART.

get closer

Fo

Though the feelings you
unlike any you've ever
critical relationship in y
speaking, is the one you
shooting these power
expressing your feelings
success rides on your u
your camera can and ca

I'm not going to explai
You don't have to under
Just become comfortal
yours. By whatever metl
help from a friend, or a
nical representative at a
manufacturer—learn ho
focus. It may be two
Whatever your camera'
is, you need to know it.
as your camera will

FOC

Here's an assign
mine how close
camera and se
important: Ple
getting comf
camera foc

cusing close-up

have for your baby are
experienced, the most
our life, photographically
have with your camera. In
ful close-ups—that is,
with your camera—your
iderstanding of how close
n't focus.

h here how cameras focus.
stand cameras in general.
le with one camera—
od—instruction manual,
conversation with a tech-
camera store or camera
w close your camera can
inches or several feet.
minimum focus distance
Get as close to your baby
illow.

US TEST

nent to help you deter-
you can get with your
why getting closer is so
ase spend twenty minutes
irtable with the way your
ises.

The assignment is simple: Shoot four pictures of your baby. In all the pictures, focus on your baby's eyes. Shoot one from six feet away, one from three feet away, one from 18 inches, and finally one from a foot. Do your best to keep your baby's eyes in focus.

FOCUS TEST RESULTS

Whatever the results of this test are—if the photos are all tack-sharp or if they're all out of focus—you are going to learn something about how your camera focuses. You are going to understand its limitations and, therefore, *your* photographic limitations. You and your camera are in this together. If your test pictures are complete failures, shoot another round of tests. Amateur photographers who are visually and technically confident enough to shoot good close-ups are in the minority. Try to put yourself among them.

If you've taken a couple rounds of tests and are still unhappy with the test results, maybe you've learned that it's time to terminate your relationship with your camera and buy a new one. Baby photography is too much fun and potentially too satisfying to let the wrong camera keep you from enjoying it.

S CLOSE TO YOUR BABY
R CAMERA WILL ALLOW.

A BIT ABOUT BACKGROUNDS

I haven't said a word about backgrounds, but if you get close enough to your baby when you're taking pictures, I almost don't need to—the backgrounds will be minimal. But I need to mention them anyway.

I'm talking about extraneous lamps and trees and tricycles and fire hydrants and street signs and cars and Washington Monuments sticking out of babies' heads and TVs and lawn furniture and just plain stuff—all of the visual clutter that distracts from the subject, your adorable baby. Bad backgrounds are chronic in the photographs of amateurs. As a professional, I probably spend more time thinking about what's in the background than what's in the foreground. A bad background draws the life out of an otherwise vibrant photograph.

Not to worry. Getting very close to your baby solves the background problem. First of all, there is a lot less of it. You have wisely cropped it out of the picture. Your picture goes from 90 percent background/10 percent baby to 90 percent baby/10 percent background. You have successfully filled the frame with baby.

Second, the background will usually go out of focus when you're very close. The closer you get, the more out of focus the background becomes. For the purposes of making babies look like the angels they are, an out-of-focus background is ideal.

You need to get really close.

You'll realize that you have found an incredibly powerful way to express your love when you dazzle your family with your first great close-up.

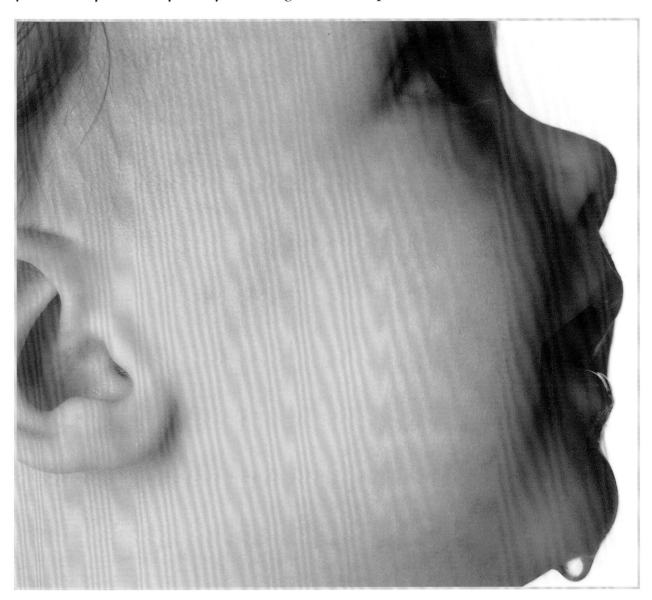

If the only adjustment you make in your photography after reading this book is cutting the distance between you and your baby by three-fourths, the quality of your pictures will leap from merely okay to frame-worthy. You will be amazed at the difference getting *very* close up makes.

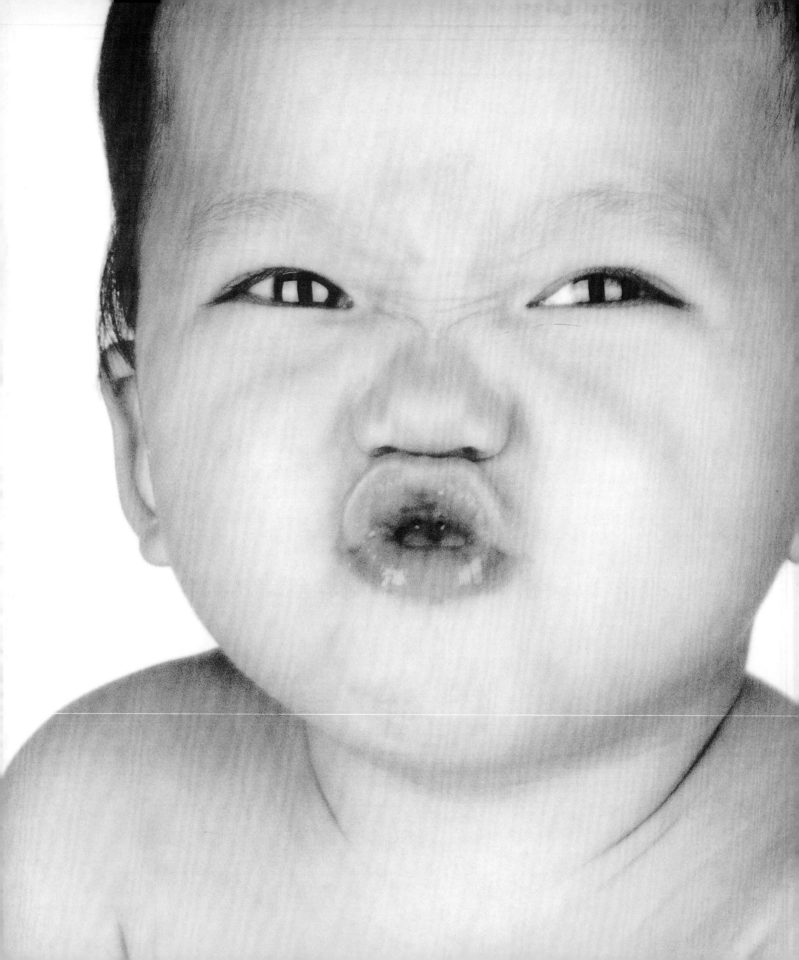

More tips to help you get closer

USE SOME LOVING AGGRESSION

Most people's understandable resistance to getting closer has to do with insecurity. Photography is not just intimidating for the subjects. When you feel like you don't know what you're doing—in this case shooting photographs—it's difficult to do it aggressively.

That's what I'm asking you to do—become lovingly aggressive with your camera. When you're getting close to your baby's face and you feel yourself becoming slightly uncomfortable, you're probably approaching the barrier that separates good baby photography from bad.

FOCUS ON FUN

If you loosen up you'll have more fun, and finding the humor in the situation will help you do both of these things. Behind the camera is an insecure, intimidated adult. In front of the camera is your baby—a defenseless, possibly naked, and yet totally liberated and uninhibited free spirit. Fortunately, the baby's indifference works only in your favor. Your baby absolutely couldn't care less how close you get with your camera, much less what the final photo looks like.

TRY THIS SIMPLE FORMULA

Over the years I've photographed hundreds of children. Their parents often tell me that I've captured the child's personality or that somehow I was even able to put a bit of their soul on film. Of course, it's all very flattering—I smile sheepishly and thank them. What I don't tell them is this: These pictures are produced by following a simple formula. Here it is:

I place the baby in some flattering soft light—often so we are both sitting sideways next to a window (one side of the baby's face is light and the other is in shadow). I get the baby to look into the camera, though I don't necessarily try to get a smile. Then, I get very close.

With all due respect, Rembrandt built a career around this technique.

The photographs leave moms and dads thinking I possess some insight into the nature of childhood. Of course, I let them think that—I'm no fool—but trust me, it's a cheap photographer's trick. These seemingly perceptive portraits are nothing more than nicely executed close-ups in good light, and in the amateur world, pictures like these are so rare they leap from the pack. Although it's just a trick, it works beautifully. The reason is this: The soft, flattering light—and the shadows that it produces—create strong emotion and mood. Nothing is more compelling to us than a dramatic look at another human face, and when that face belongs to your baby the impact is downright profound.

Professional photographers tend to have a cavalier attitude toward pushing the button. Shooting lots of photographs—the lifeblood of photography—is so basic to successful picture taking that professionals don't even think about it. In the old days, film was the last place professionals cut corners. They treated film like tissues: if they needed more, they simply used more. If taking one more roll would let them sleep the night after a big shoot—knowing they've done everything possible to get the very best picture—they would knock off another roll of thirty-six exposures with no hesitation.

Now, in the digital age, the cost of shooting ten pictures or one hundred is practically the same. (Yes, it's true shooting more pictures requires more battery power, but that's splitting hairs.) Now the downside of shooting lots and lots of pictures is that you have to store them someplace; there is still no excuse for being reluctant to take more pictures.

And amateurs have a natural reluctance to "work a situation." They act as though every frame on every roll is a priceless gem, as though they're scared to make any mistakes, which, of course, is a mistake in itself. Amateurs need to acquire the photographer's second most valuable tool—after a great set of eyeballs, that is. It's a relaxed shutter finger.

I compare relaxing your shutter finger to dancing. When you're really dancing—when you're really connected—you just do it. Neither partner wonders where they're going next. They just go there.

In photography, as in dancing, when you hesitate, you stumble. Spontaneous photographs require not just spontaneous events, but spontaneous photographers—photographers who don't think too much about when to push the shutter button. They just push it.

Thinking too much can get you into trouble. In the time it takes to think a thought, wonderful photographs come and go: the look of shock as a door slams, a baby's sneeze, the first blast of a sea breeze in a baby's face. Here, and then gone. Don't think. Just push the button. Dance with your shutter finger.

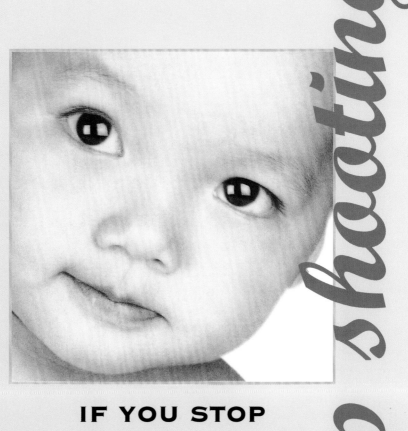

IF YOU STOP

SHOOTING,

YOU'LL START

THINKING.

BIG MISTAKE!

keep shooting

A PHOTO SESSION

If you're like most parents, you probably believe that having your baby photographed, either by you or a professional, is a necessity. Let's consider the options:

1. HIRING A PHOTOGRAPHER

The range of talent and prices here is off the charts in both directions. But I know this for a fact—if someone says they will do it for less than a hundred dollars, keep shopping. (I know a guy who will paint your car for $69.95.) And if you hire someone whose work you love, it will probably cost several hundred dollars. They will also own the photographs (the digital files or negatives) and may charge you a bundle for each print.

2. TAKING YOUR OWN PHOTOGRAPHS

I'd like you to take one hundred pictures in around 30 minutes. Back in the old days (a few short years ago, that is) the cost of film and processing was a big stumbling block. Digital photography has eliminated that problem. And don't be too quick to assume that your pictures will not be as good as a professional's. A concentrated 30 minutes of photography with a liberated shutter finger could very well change your mind. Let's compare the pros and cons of doing it yourself.

CONS:

- Your computer may end up at the city dump with your baby photos in it. (*Always, always* back up all of your photographs onto an external hard drive. I keep mine in the trunk of my car.)
- You could shoot terrible pictures and embarrass yourself in front of your baby. (This book will help ensure that this doesn't happen.)

PROS:

- Your shooting fee is zero.
- Even less-than-perfect photographs will be treasured by you and your children.
- You will own the digital files and can do anything you want with them.
- The potential satisfaction is enormous.
- You have 24/7 access to your baby and can have the photo session when you and the baby are really ready.
- A good photo session can solve all of your holiday gift-giving problems in one fell swoop.
- And finally, if the session is a disaster and you decide that I'm an idiot, you can always hire a photographer.

This set of photographs, taken by my good friend Barbara, is a perfect representation of the way so many amateurs approach photography—there are one or two photographs of several different situations, and yet it's difficult to pick one image that jumps out of the pack. They all seem to be equally lacking in impact (impact is what professionals strive for). My advice: When you see something good—work it. Knock off fifteen or twenty frames. ("Work it" and "knock off some frames" are professional terms that will build your confidence if you use them.) I guarantee that your refrigerator photographs will begin to draw comments and smiles.

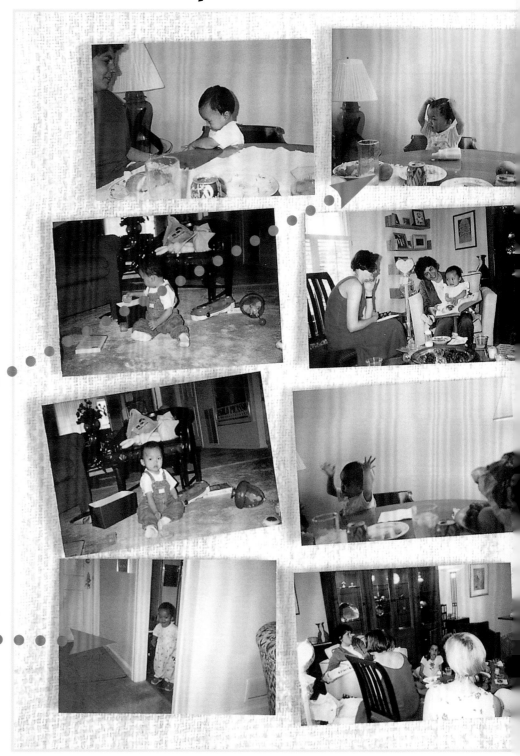

Lots of visual clutter.

Most amateur photographs feel like missed opportunities to me. I think Barbara became so engrossed with whatever cute thing her baby, Alexis, was doing at the moment that she failed to notice the dirty dishes in the foreground and the big blank wall behind her. All of us are surrounded by visual clutter. Just fill the frame with baby. This doesn't just clean up backgrounds—it removes them. Getting closer solves so many problems.

Missed opportunity.

This is another situation with lots of potential—Alexis peeking out of a door. Barbara could have played peek-a-boo with Alexis and shot several frames to capture her baby's playfulness. And, of course, she needed to be much closer.

DON'T THINK. JUST PUSH
THE SHUTTER BUTTON.

What a professional photo session looks like

e—and why. (Does this look familiar?)

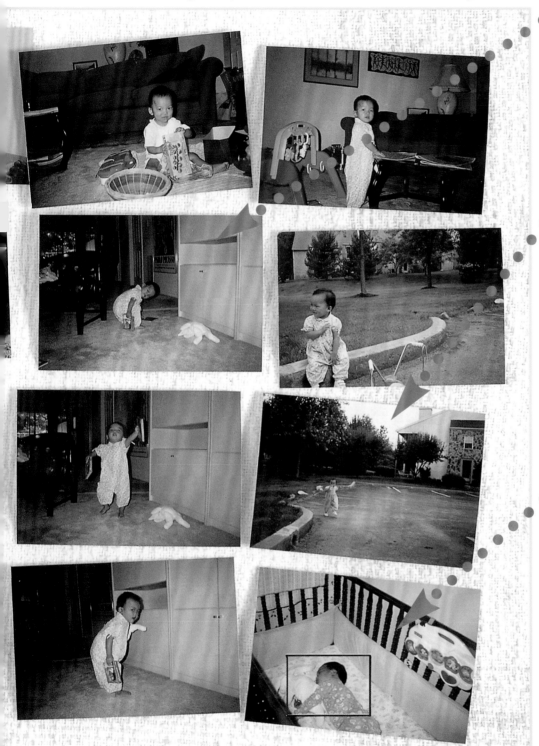

Closer, closer, closer.

Fill the frame with your baby and shoot a dozen frames. Alexis, like lots of babies, is a little ham and loves to make faces at the camera. Let your baby be a ham and just keep pushing the shutter. You're going to get something terrific if you do.

Alexis gets lost in this photo.

This is a picture of a baby that is actually about 5 percent baby and 95 percent parking lot (though it's a lovely lot). Amateurs shoot millions of these pictures every year. Don't get me wrong—Alexis bopping around with a bottle in her mouth is a cute situation. But if I were shooting it, I would probably knock off fifteen to twenty frames. You will be amazed by the lucky shots that show up on your screen when you take lots of photographs without stopping to think.

A sweet moment—almost.

Barbara's heart was in the right place when she tried to record this sweet moment between a child and a stuffed bunny, but I'm afraid it came out looking like an ad for crib bumpers. (Sorry, Barbara.) The picture was there; it was only a matter of getting closer and, well, working it.

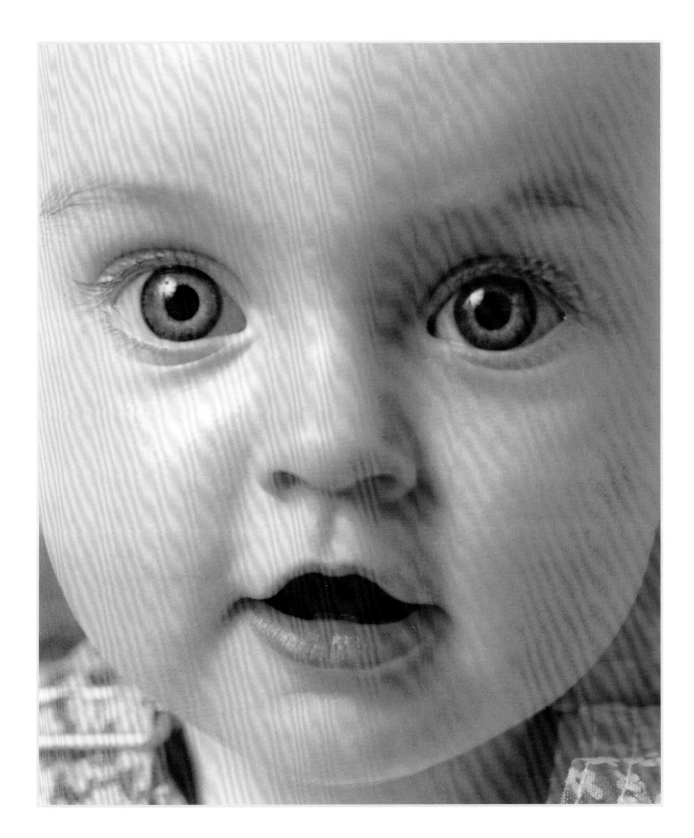

ost amateurs who purchase point-and-shoot cameras wisely buy one with a built-in flash. It was put there by a responsible camera manufacturer whose goal was to help you produce photographs easily. Having made that point, I realize the irony of what I'm about to say: That flash is destroying your pictures.

It's a curious statement, yet every professional photographer I know believes it. It has to do with what photographers call the quality of light. This is not to be confused with quantity of light—that is, how bright or dark something is. The sun has a large quantity of light and a cave does not. Quantity of light can be accurately measured with a light meter.

Quality of light is intangible. It has to do with emotion and mood; it can't be measured. The quality of candlelight is soft and beautiful. Just about everyone looks better in a room lit by candles. The quality of headlights is harsh and unflattering. On the quality-of-light scale your electronic flash is closer to the automobile headlight than to the candle. The quality of light produced by the flash on your camera is, to put it mildly, unattractive.

So when I say that the flash is destroying your pictures, I mean that it's keeping you from taking really beautiful photographs of your baby. It's the difference between professional work and amateur work. Professionals spend years developing the artistic ability to judge the quality of light and what it will look like in photographs; many amateurs don't know there's a difference.

I'm not silly enough to ask the parents of newborns to become sensitive to beautiful lighting overnight, but in the next foldout, "The Right Light," I'm going to show you specific locations where it always exists—you won't have to think about it. Then, try to find a quiet thirty minutes, turn off your flash, bathe your baby in this light, and experience the thrill of taking photographs you never thought possible. This section helps illuminate the reasons why flashes ruin baby photographs.

IT'S

DESTROYING

YOUR

PICTURES.

turn off that flash

SPONTANEOUS PHOTO OPS— WHEN FLASHES ARE HANDY

So if the flash on your camera is destroying your pictures, why is it there?

First, and most important, it allows you to take photographs under just about any lighting conditions. The pictures created may not be pretty, but sometimes not-so-pretty pictures are better than no pictures at all, and that's what you would have if you didn't have the flash.

If the flash wasn't there, you would have difficulty photographing those spontaneous events when you have no control over the lighting—birthday parties or spaghetti-and-meatballs-on-the-baby's-head moments (do babies really do that?) or other wonderful family times.

The flash provides you with enough light to take sharp pictures in low light. It raises the quantity of light; it does not raise the quality of light—it usually lowers it—but there are times when getting the shot, no matter what the quality of light, is more important.

And that little flash—an engineering marvel, really—is so convenient. When you pick up your camera, you've already dealt with any light quantity problems. You don't have to fumble with cords or flashbulbs or attachments. Modern technology allows us to point and shoot with remarkable results.

As I said, every professional I know thinks that the built-in flash destroys the mood in pictures. Did I fail to mention that every pro I know also owns an idiot-proof, auto-focus, auto-exposure snapshot camera with a built-in flash and loves it?

It's the only camera I take on vacation.

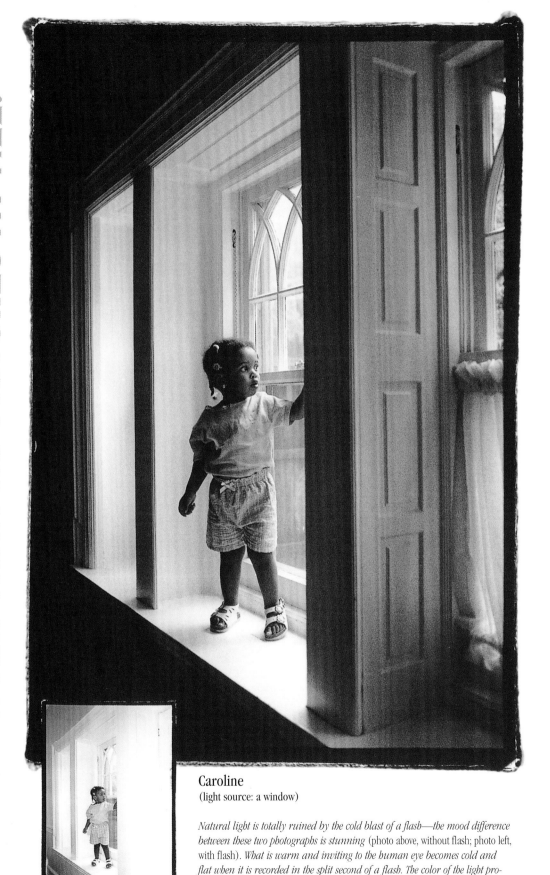

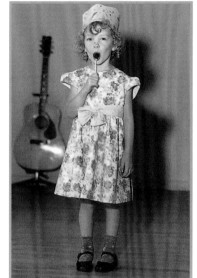

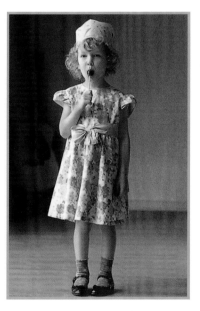

Caroline
(light source: a window)

Natural light is totally ruined by the cold blast of a flash—the mood difference between these two photographs is stunning (photo above, without flash; photo left, with flash). *What is warm and inviting to the human eye becomes cold and flat when it is recorded in the split second of a flash. The color of the light produced by the flash is much bluer than the slightly orange light coming in the window—two very different emotional effects.*

Emily
(light source: a window)

A flash also produces unexpected and unpredictable glitches in your photographs. Most photographers would never think to move the guitar out of the way before taking the photograph—after all, it's hidden in the shadows (bottom photo). *But when the flash goes off* (top photo), *not only does it ruin the dramatic lighting on Emily, but it also creates an ugly reflection on the guitar.*

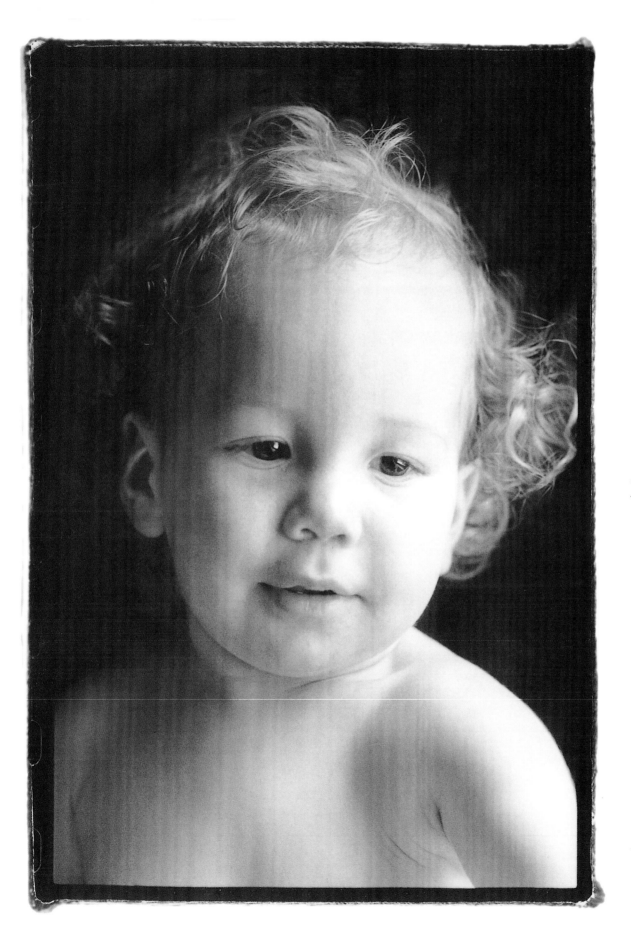

Andrew
(light source: a window)

One of the most practical aspects of using natural light is that you can see it. What you see through the camera is basically what you get in the picture. A flash, however, changes the look and mood of everything. Nothing looks like, well, reality.

The flash is actually so much brighter than the window light that it completely blows it away. That little flash is intense. For a split second, the room is filled with a light almost as bright as the sun. The window can't compete. Imagine shining a bright spotlight into the face of someone who is lit by candlelight. It's the same effect, technically and emotionally speaking.

The picture on the left (taken with a flash) is cold, while the picture on the right (taken without flash) actually has the feel of a timeless painting. The swirling hair, the slight gaze away from the camera, and the dramatic window light add up to a portrait of an angel.

PROFESSIONALS SPEND YEARS DEVELOPING THE ABILITY TO JUDGE THE QUALITY OF LIGHT. MANY AMATEURS DON'T KNOW THERE'S A DIFFERENCE.

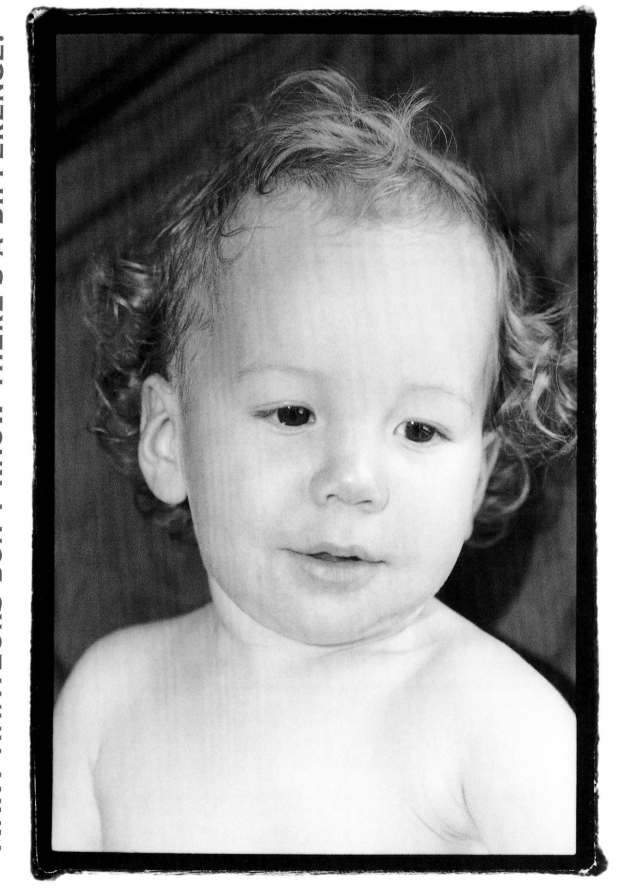

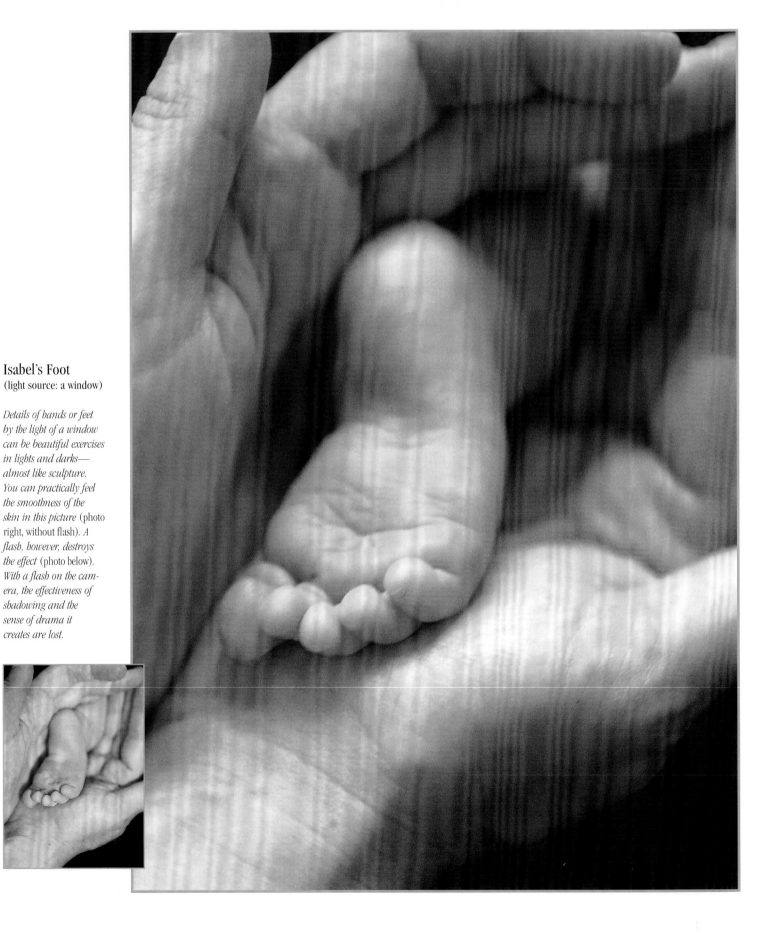

Isabel's Foot
(light source: a window)

Details of hands or feet by the light of a window can be beautiful exercises in lights and darks—almost like sculpture. You can practically feel the smoothness of the skin in this picture (photo right, without flash). *A flash, however, destroys the effect* (photo below). *With a flash on the camera, the effectiveness of shadowing and the sense of drama it creates are lost.*

Evan
(light source: a door)

Evan was sitting next to a large patio door when these pictures were taken. They were taken less than a second apart, and yet one of them seems to say something about the spirit and mind of a two-year-old and the other one just feels like a snapshot— which it is. Notice how the flash lit up the background (photo below), completely eliminating the mood of a little boy surrounded by darkness. Exactly the same chair, exactly the same boy; the only difference is the lighting (photo right, without flash). Ironically, when we added light to the situation, the mood was completely destroyed.

I make no pretense as to what is about to happen—we are going to steal from the master. If Rembrandt had written a set of instructions or drawn a map to guide us to beautiful light, it could not be any clearer than the directions he left us; he painted us pictures. Artists and photographers ever since have copied his technique—using flattering, soft light to create dramatic shadows—to produce stunning work. I don't know why we shouldn't do the same.

Just about everyone who sits in Rembrandt's light is transformed from just another face in the crowd to an artistic statement reflecting the essence of humanity. What makes this method so simple and elegant is that this light is everywhere. You don't need to leave home to find it. Just about every outdoor window, door, porch, alcove, or garage is a shrine to beauty. Your house or apartment has several locations waiting for a masterpiece to happen. I'll guide you to them.

Picture this: The sun is shining brightly. Sidewalks and streets and lawns are all reflecting the midday sun. Sunglasses are almost required. Somewhere in your home is a room that's brightly lit by this reflected light from outside. Direct sunlight is not coming into the room, but the room is still bright and beautiful because it's so bright outside. Near the window or open door of that room is the light we're looking for. Hold your baby there so that one side of your baby's face is light and the other is dark. It's that simple.

Remember, the light you're looking for is not direct sunlight. Direct sunlight produces hard-edged shadows. You're looking for soft light that is easy on the eye. The shadows it produces are soft-edged and gradual. You may think that there is absolutely nothing special about this light. After all, we are surrounded by it. That's actually a large part of the problem in teaching someone to observe it. It's so commonplace that we become jaded to its beauty—and some never see its beauty in the first place. But wait until you and your baby have a photo session in this light and you see it in your photographs.

Personal masterpieces await.

THE SECRET IS

WHERE TO FIND IT,

AND REMBRANDT

KNEW THE SECRET.

HE EVEN DREW

US A PICTURE.

the right light

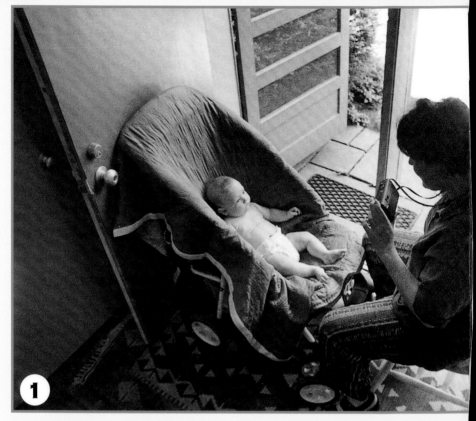

WHERE THERE'S GREAT LIGHT

Here are the results of our search for great light in and around the home. As you can see, these locations are perfect for picture taking and require minimal preparation to set up. They provide the kind of dramatic light in which you can take compelling portraits of your baby.

1. THE DOORWAY

An open door can be a great place to take photographs. Not only is the light right, but the door itself is a built-in background. The simpler the door, the better. If the door itself is not to your liking, and you'd prefer not to see it in your photos, just drape a background cloth over the door.

2. THE GARAGE

Beautiful light presents itself in the most unexpected places—including your garage. Unbelievably enough, out there with the lawnmower and the golf clubs is a photo studio waiting to be used. When the sun hits the driveway outside the garage door, lots of the light we're looking for flows inside. Position your baby as close to the garage-door opening as possible. You will almost surely have to hang a piece of cloth—a blanket or towel—as a background to cover up the clutter. But it's worth it. A big garage door on the right day may be the best home studio space there is, and it couldn't be any easier to use.

3. THE PORCH

Porches are nice because they let in so much light and they're big enough so you can be choosy about your spot. Make sure you wait for a sunny day when the area around the porch—that is, the grass and trees—is bright with direct sunlight.

4. THE CAR

Your automobile as a photography studio? Yes, and it's portable. You can take the studio to where the light is. If you park your car next to a wall that's in direct sunlight, the glow from that wall will fill the automobile interior with beautiful soft light. Put your baby in the back seat next to the window closest to the bright wall. Bonus: Your baby is strapped down in the car seat and can't run away.

5. THE WINDOW

The classic location. Rembrandt must have spent years hanging out at windows just watching the light change. Taking pictures by windows is always great when the light is right, but if you live in the northern latitudes, the light coming into your windows after a fresh snowfall is absolutely magnificent. For those of you who live in apartments, the best time to take pictures by a window is when the building across the street is being hit by direct sunlight (your building receives the reflected light).

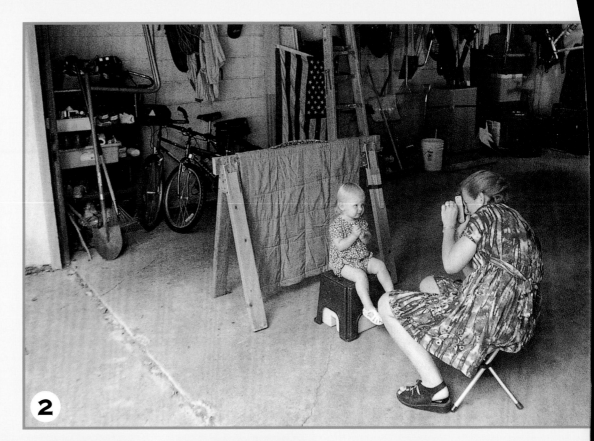

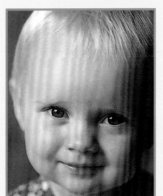

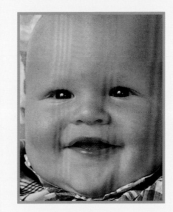

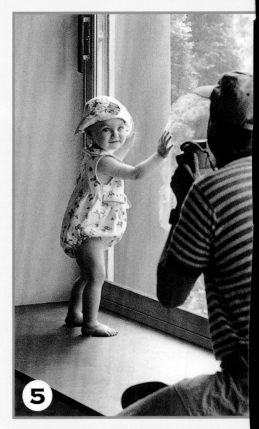

Clockwise from top left: the doorway, the garage, the porch, the car, and the window.

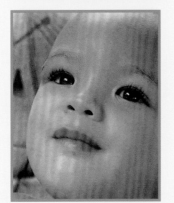

JUST ABOUT EVERYONE WHO SITS IN REMBRANDT'S LIGHT IS TRANSFORMED.

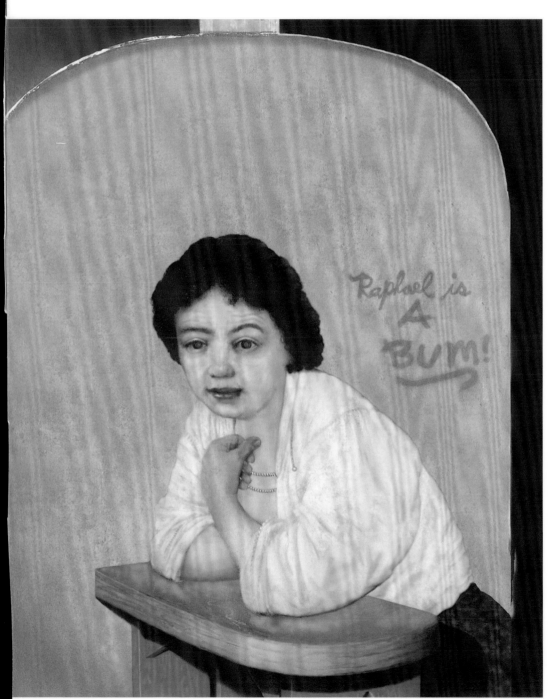

Girl at a Window
Rembrandt van Rijn
1606-1669 Dutch
by permission of The Trustees of
the Dulwich Picture Gallery, London

Just so there would be no doubt about where to go to find the kind of light you see in this painting, Rembrandt hits us over the head with it, entitling the painting Girl at a Window. Rembrandt did what I'm encouraging you to do—he set his subject in the most beautiful light he could find and recorded what he saw with paint. When you turn off your flash, you can photograph by the beautiful light that is at hand, the light you can see. Of course, you can also see a flash flashing, but you can't see the visual damage it's doing to the scene.

Imagine what a Rembrandt painting would look like if he had captured what your camera sees when the flash goes off. It would look something like the image at the near right. The drama is gone. The subject looks pasty and flat. If Rembrandt had painted portraits like your flash makes photographs look, he would have spent his career painting barns instead of masterpieces.

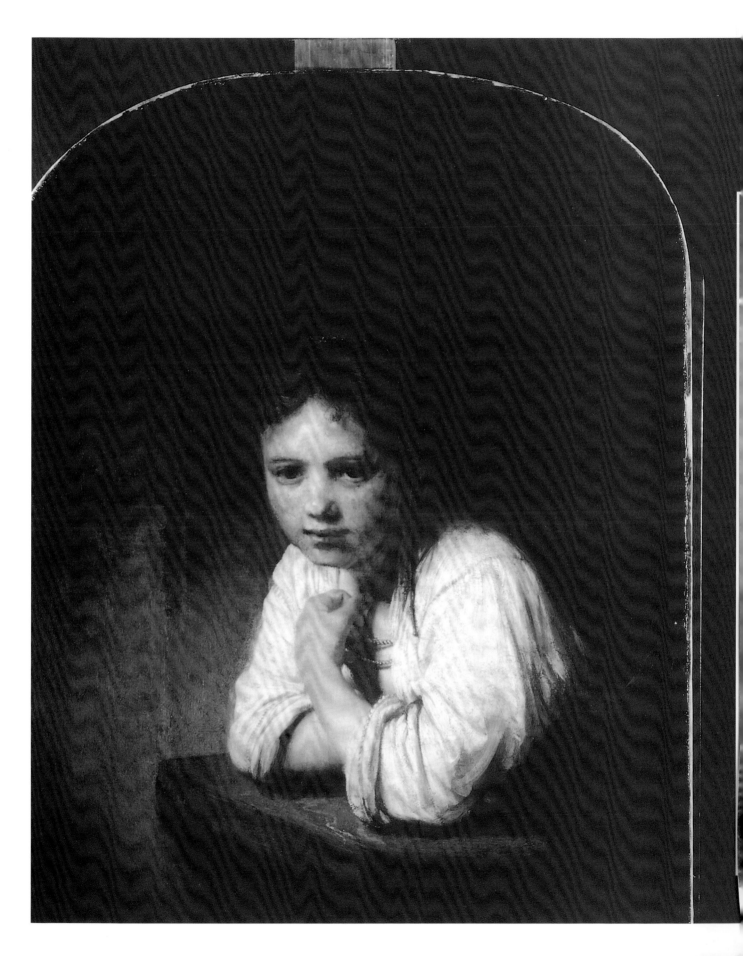

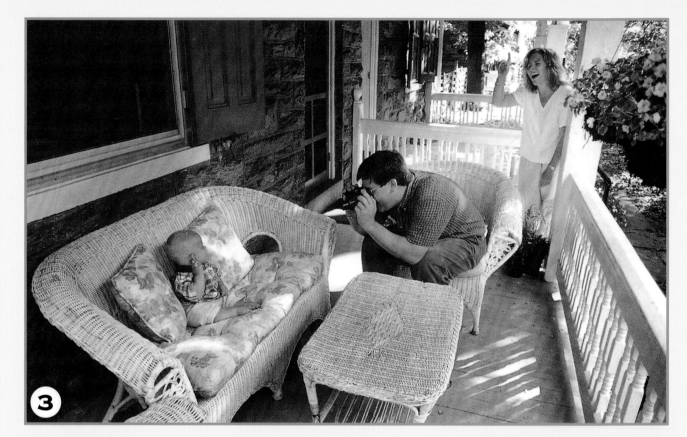

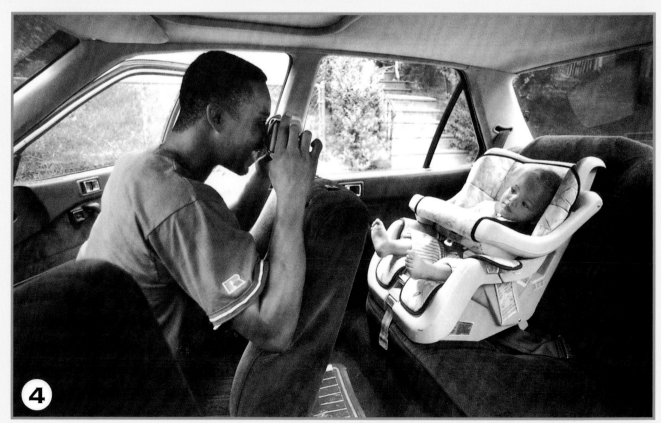

More photo ops

(ESPECIALLY FOR THOSE IN LIGHT-CHALLENGED LIVING SPACES)

I realize there are many of you who may not have a garage or a porch, or whose front door opens up into a poorly lit hallway. I've lived in an apartment myself and there is no question about it—it's harder to find great light. But the situation is far from hopeless. You just need to be a little more flexible—and creative. Here are some suggestions that should help.

LAMP LIGHT

You can create dramatic light in your apartment by using a lamp with a lampshade. Put a bright light bulb in a lamp (100 watts is good) and tilt the lampshade so the light shines toward the baby. Move the lamp close to the baby and off to one side (see photo at left). You may want to do this while your child is sitting in a highchair so he or she can't grab the lamp and tip it over. The color produced by a lamp is warmer, or more orange, than light from the sun. Warm-tinted portraits such as those you'll produce with lamplight are beautiful, so don't worry about using this "artificial" light.

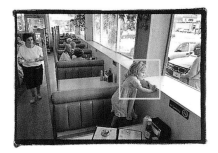

DINER LIGHT

Whenever I'm sitting at a window seat in a diner, I'm aware of the beautiful light on the faces of the people across from me. Aside from serving up comfort food (the greasier, the better), diners are also great locations for shooting photos of your baby. Go midmorning on a sunny day and find a window seat. The crowd will be thinned out, the light will be pouring in the window, and if you get the right waitress, she will even help hold your baby's attention.

TRAIN LIGHT

Pictures of babies looking out of windows are almost always compelling—it's a classic situation that seems to capture their natural curiosity. Taking your camera on a train ride with your child could really pay off. There's plenty to hold a child's attention outside the window and the light is constantly changing. The biggest problem is the shaking of the train when it pulls in for a station stop.

A sense of humor is almost mandatory for successful baby photography, because lots of unexpected things happen and the only appropriate reaction is to laugh. I hope this section gets you loosened up and in the mood to have fun taking baby photographs.

A Foolproof Way to Make Your Baby Smile Every Time

It has been my experience that babies love to make people laugh. You can use this charming inclination to manipulate your baby into producing that Holy Grail of photography—the spontaneous baby smile. The loving ploy described here gives your baby his first gratifying laugh from an audience. I know it sounds strange that an infant could derive satisfaction from performing comedy, but if you know babies, the story rings true. Not only does the audience laugh, but the baby laughs, and that's the point. If your goal is to photograph a very happy baby, this method always works. Guaranteed.

I generally recommend that people be alone with their babies for picturing taking, but for this stunt, you need a small audience—about three or four adults or older children. You also need a set of keys (you should probably clean them). I have photographed many babies and I have never met one who wasn't fascinated by a set of keys.

How the Make-Your-Baby-Smile Ploy Works

First, get your camera ready. Confirm that the settings are where you want them. Then sit your baby down in beautiful light. Gather the audience around the baby. They may smile politely at your baby, but for maximum effect they must not under any circumstances speak, particularly with any of those supposedly funny voices that adults use to entertain babies. After a short time, the baby starts to fidget. The photographer shakes the keys in front of the baby and, much to the baby's delight, allows the baby to play with them.

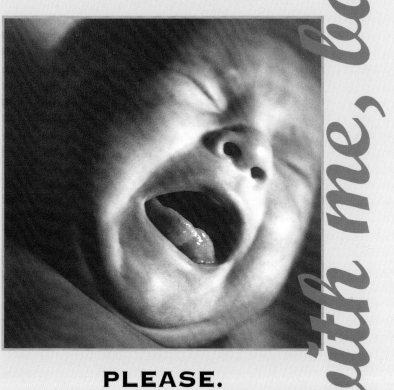

PLEASE.

I'LL LET YOU

PLAY WITH

MY KEYS.

work with me, baby

MORE PHOTO SESSION TIPS

baby does
your heart.
turn away.

1 Crying is okay.

A big baby smile isn't the only great thing to photograph. Babies crying and drooling and sneezing are all wonderful as well. Yes, babies are cute, but they're also mysterious and stubborn and unpredictable, and it all looks good in photographs.

2 Looking at the camera isn't necessary.

If you decide not to try to get your six-month-old to look into the camera, your life will be much easier. Go with what your baby is doing. If he looks out the window, photograph it. If she examines her toes, photograph it. In short: Your baby doesn't necessarily have to look into the camera.

4 Fe Feed th

I'm not sure
even consid
the two stor
milk should

3 Turn your back.

When you're changing batteries or media cards, turn away from your subject. You don't want to see some super-cute baby expression when you can't photograph it. It's like throwing salt in a wound. What your

5

Visually
a distrac
and I se
photogr
glows.
made
baby

...hen your battery is dead will break ...Make sure your baby is safe, and then

...ed the baby.
...e photographer.

...who is more important here, but don't ...r trying a photo session when either of ...achs is empty. Graham crackers and ...be in every photographer's gadget bag.

...Get your baby naked.

...speaking, clothes on a baby are often ...tion. Baby skin is smooth and sweet, ...no reason to hide it—and when you ...aph it in the right light, it practically ...I have seen baby photographs that ...me think I could actually smell the ...'s skin.

5A Get your baby naked early to avoid red marks.

If you photograph a naked baby, take your baby's clothes off twenty minutes before you want to shoot. The elastic bands on diapers leave red marks, and it takes about twenty minutes for them to disappear.

6 Choose your time wisely.

No one knows better than you when your baby will be most cooperative. I have found that for lots of babies, it's midmorning. They're rested. They're full. They're incredibly beautiful.

7 Break up the session.

Be ready to take some breaks. If it's not working, you can't force the situation—the more you push yourself, the less enjoyable it will be, and your photographs will probably suffer for it. Shoot some pictures, put the camera down for a while, shoot some more pictures. Do what feels good. Sometimes a nap is the only answer.

8 Us...

The governo... once signed ...tion a bill tha... every newbo... with a CD ...music's grea...

benefits to young children of listenin... music are widely acknowledged. Repe... and melodies stimulate brain activity a... a photographer, I have seen the rela... music on both my little subje...

9 Squeaky to...

It's tough to beat the classics. K... stuffed animal or a toy handy for when... rough, but don't give it to your baby at... of the session. You only have so many... need to play them wisely.

10 Fingers and toe... and backsides.

If your camera can focus close eno... many point-and-shoots do have a "m... now—you can fill the frame with little... baby's body, such as ears and rolls... bath, when the bottoms of your baby's... prunes, is a great time for "footograp...

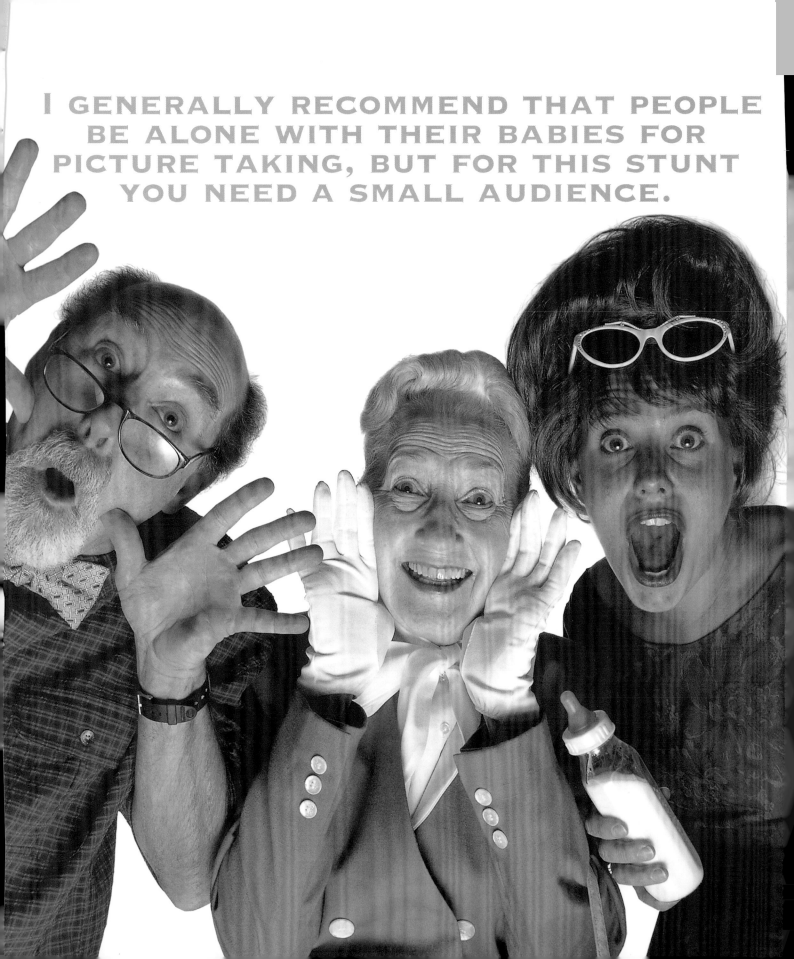

The audience members must remain silent as the baby orally washes the keys.

Sooner or later, the baby will throw the keys.

As soon as the keys hit the ground, the audience laughs and claps enthusiastically—not too loud (you don't want to frighten the baby), but just enough to give the baby a first taste of celebrity. The baby may or may not laugh at this point. It doesn't matter. You're still laying the groundwork. The keys are returned to the baby. Now it gets interesting. This time, when the baby throws the keys, the audience remains silent. The baby becomes frustrated. You are now giving the child a sample of what it's like to bomb in front of a tough crowd. The keys are returned to the baby. The baby throws them again. The performance is met with crushing silence. The baby is frantic for that audience approval again. Desperately, the baby throws the keys. This time, to everyone's relief, the audience erupts into enthusiastic laughter and applause. The baby is all giggles.

Now it's one great photo after another, like shooting ducks in a pond.

You've got your baby in the right place; for the moment, the baby lives for applause, and the audience alternates between laughter and the silent treatment. For the next few minutes, until the baby becomes totally bored, you can make your baby laugh at will. Whenever the audience laughs, the baby will laugh.

This method is lots of fun, and it'll work every time.

music.

of Georgia
into legisla-
will provide
in the state
of classical
est hits. The
to classical
itive rhythms
d growth. As
ng effects of
s and myself.

work.

p a favorite
he going gets
he beginning
ards and you

gh—and
acro" setting
etails of your
f fat. After a
eet look like
."

11 *Keys.*

The secret weapon. I've never met a baby who didn't love to play with them. They can make even a crying baby smile. (See "How the Make-Your-Baby-Smile Ploy Works.")

12 *The crowd approach.*

Four adults simultaneously yelling at a nine-month-old to smile and look in the camera is pretty silly. On the other hand, if they are working together it can be a beautiful thing. (See "How the Make-Your-Baby-Smile Ploy Works.")

13 *Ten months is the perfect age for a photo shoot.*

When babies can get up and walk away, it's like trying to photograph a polo match—and how many good polo photographs have you seen? When they can sit up but aren't yet old enough to escape, it's easy to get great photographs.

14 *Know your camera.*

Learn how to use your camera when your baby is sleeping. Have the camera loaded and ready when your baby is awake.

15 *Go for the really good stuff.*

Two or three great pictures a year is probably enough. If you framed two wonderful pictures of your child every year until the age of twenty-one, you would have . . . well, you probably don't have the wall space.

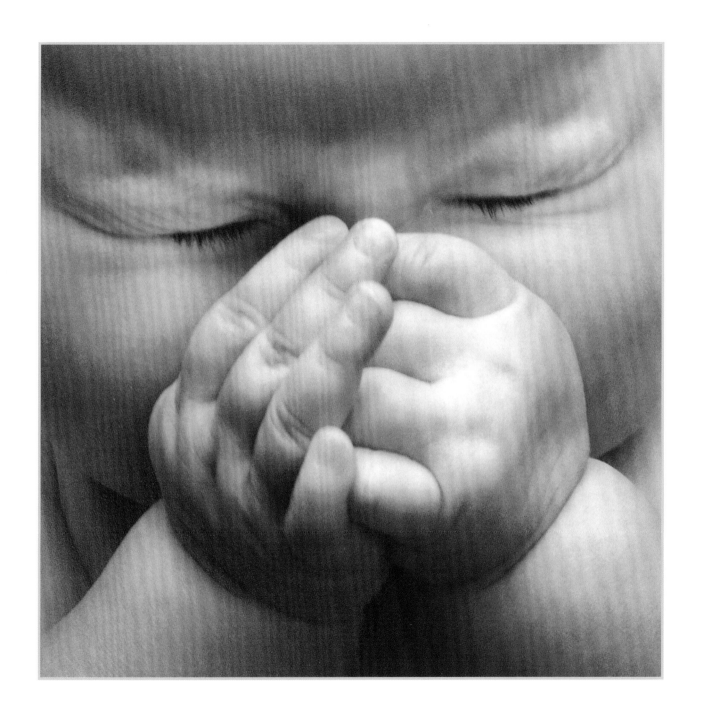

A BIG BABY SMILE ISN'T THE ONLY GREAT PHOTO.
BABIES CRYING AND DROOLING AND SNEEZING
ARE ALL WONDERFUL.

The photographer's most important piece of equipment is the heart—it's more important than any gadget in a camera bag or any helpful advice. I've never seen better evidence of this than in a story I heard not long ago. It's a tale about the loving use of photography. The actual photographs were taken with the most basic equipment. The film was processed at a corner drugstore.

This is the story of a father who began a tradition the week his son was born: He photographed his own hand holding his baby's. That was it. And every year after, sometime near the boy's birthday, he would repeat the ritual, filling the viewfinder of his camera with two hands, each of them slowly evolving over the years.

Neither of them ever brushed their hair or changed their shirts to produce a semblance of respectability. They were only photographing hands. In a quiet moment, the two of them would sit in the soft light of an open window and record the gradual effect of time on their bodies. And they did it in a way that fathers and sons rarely do—they held each other. Sometimes the fingernails revealed the effects of manual labor or the vestiges of fingerpaints. Now and then, a year was missed, and occasionally a photograph was slightly out of focus or overexposed. But it didn't matter—the concept was perfect, and all the more so for its simplicity. Driven by the love of a man for his son, the results were nothing short of profound.

At first, only the son's hand showed the passage of the years. The father's stayed strong and proud, while the smaller hand showed a youngster growing quickly into boyhood, then into adolescence. Then the decades revealed themselves in the wrinkles and contours that crept into the father's skin. By this time, the son was the photographer, and his hands, gently holding his father's, had become the symbol of strength and protection. In the last of the series, a third hand—a granddaughter's—appeared.

ANYONE CAN

PRODUCE A

MASTERPIECE,

AND IT

DOESN'T TAKE

YEARS OF PRACTICE.

a lifelong affair

Your private archive

OR, AVOIDING THE NIGHTMARE OF FILING

I can't think of anything more difficult to file than photographs. It's a nightmare. For example, where would you file a picture of your baby in front of Mt. Rushmore? Under your child's name? Under "V" for Vacations? Under "S" for South Dakota? Under the year? Or you could do what your parents did—file it in a big unlabeled box with dozens or even hundreds of unlabeled yellow envelopes.

Now your photographs live on a computer and you are going to need to start thinking a little like a librarian. In other words:

WHERE SHALL WE PUT THIS PICTURE SO WE CAN FIND IT LATER?

The answer is that you will have folders in folders in folders. Please stick with me—the next few paragraphs could save you a lot of grief. (And, yes, I still grieve for photographs I cannot find.)

• The first line of defense is to keep things simple. Eliminate the obviously bad photographs you will never want. Do you and your computer a favor. Put something in the trash.

• Then, start with the date.

• Create a folder of family photography for the month and the year. For example: "Family May 2013." It's important that, whatever format for labeling you use, you keep it completely consistent. For example, don't reverse the order of the words next month and call the folder "June 2013 Family."

• Then I create a folder for every photo session. For example: "Teddy Smiles May 5" and put that folder into the "Family May 2013." I do try to get as many "who-what-where-when" references into the titles of folders as possible: Who? Teddy. What? Smiling. When? May 5.

• But here is where this approach breaks down. The day will come when you download your camera and there are pictures of the baby *and* pictures of your new car *and* pictures of your mother at Christmas. This is when you have to decide just how compulsive you want to be.

SOME LIFE-LONG IDEAS

SPECIAL LANDMARKS

Pick a location you can return to with your child every year on a birthday or a vacation, and shoot a portrait. A city landmark or beautiful natural backdrop such as a large rock on a seacoast is perfect. Trees are nice, too, as long as the weather is good (their tendency to attract lightning in stormy weather is hazardous). Do this for years and you get to watch your baby grow up in one of your favorite spots.

FAVORITE CLOTHES

I saw this in *Life* magazine years ago. A father photographed his newborn son lying on a pair of his khaki pants and a large white shirt. Every year on the son's birthday the father pulled the same pair of pants and shirt out of storage and photographed the son wearing the clothes. At age four the boy was swimming in yards of extra fabric, at age sixteen the clothes fit perfectly, and at age twenty-one the boy's limbs were hanging out of every extremity of the garments. This was an unforgettable series of pictures, and so easy to do.

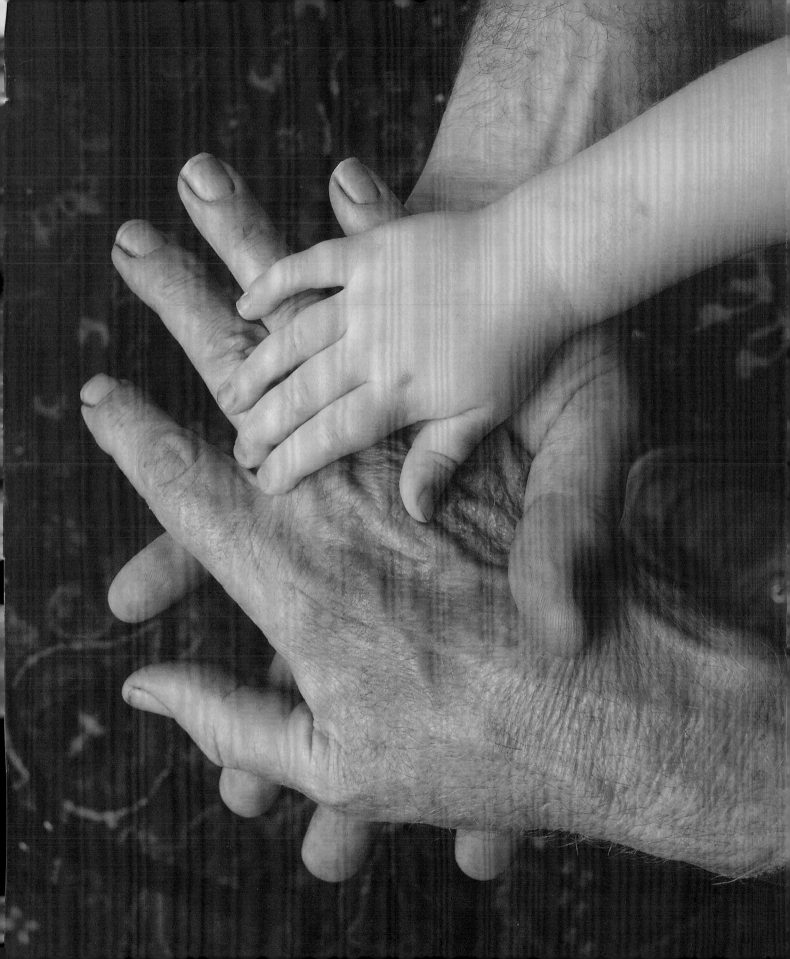

There are no faces in these pictures. There were plenty of other times to capture smiles on birthdays, holidays, and vacations at the beach. In this family's photographic archives, however, the annual hand pictures became treasures—an accomplishment most professionals never achieve. What was in the heart of the father is experienced by the viewers of the art he left behind.

These were taken by an amateur photographer with amateur equipment, you ask? The answer is yes. These photographs were taken by a blue-collar worker who would never have used the word "artist," and certainly would never have considered himself one. And yet, the man's children are left with wonderful images produced by a loving parent following his instincts and expressing his love with a camera.

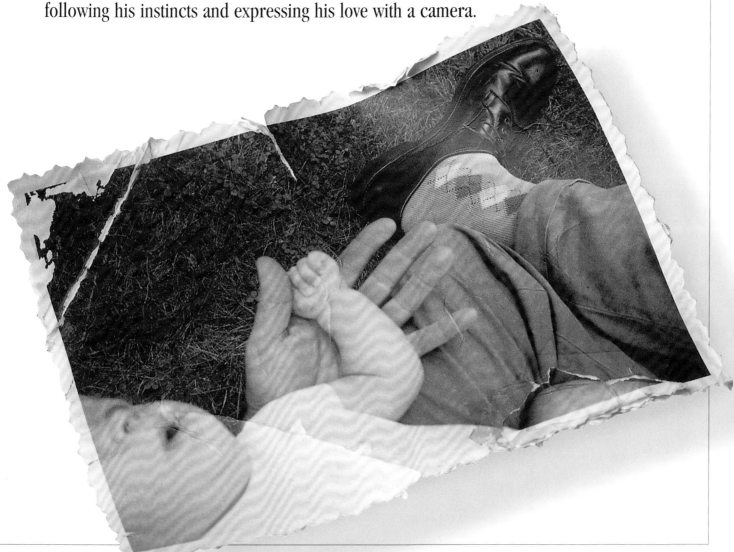

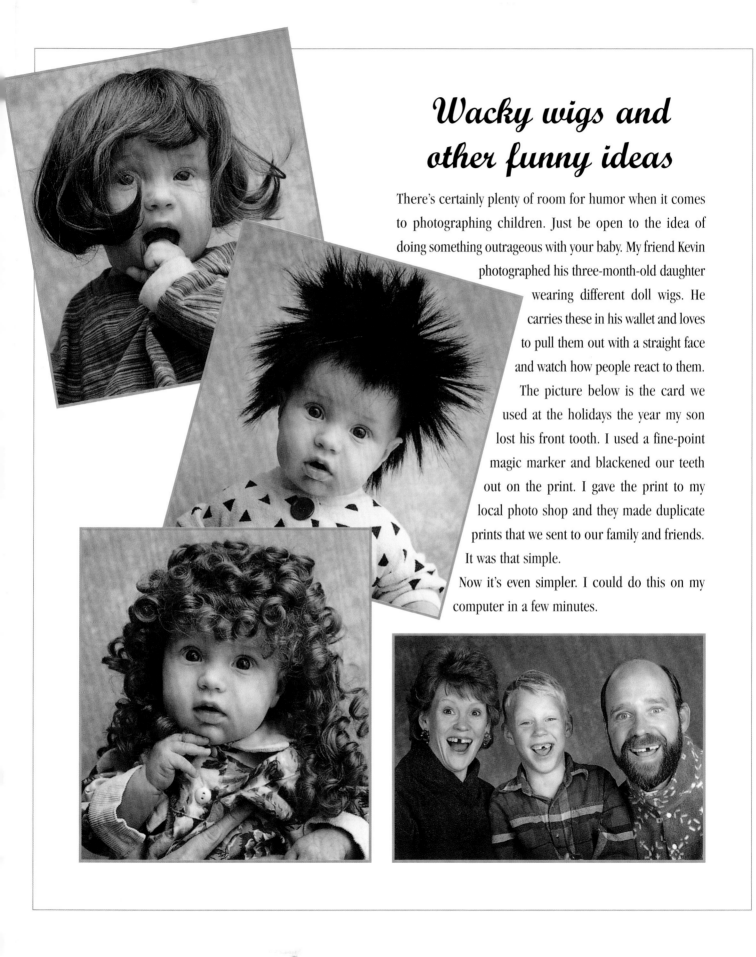

Wacky wigs and other funny ideas

There's certainly plenty of room for humor when it comes to photographing children. Just be open to the idea of doing something outrageous with your baby. My friend Kevin photographed his three-month-old daughter wearing different doll wigs. He carries these in his wallet and loves to pull them out with a straight face and watch how people react to them.

The picture below is the card we used at the holidays the year my son lost his front tooth. I used a fine-point magic marker and blackened our teeth out on the print. I gave the print to my local photo shop and they made duplicate prints that we sent to our family and friends. It was that simple.

Now it's even simpler. I could do this on my computer in a few minutes.

People often ask me if my children are the most photographed kids in the world. Considering my profession and how good looking my kids are, it's not unreasonable to think that I probably document their every milestone. The truth is, that's not even close. Several of our non-photographer friends shoot many more pictures of their children than I do.

But every Christmas there's a box under the tree for my wife containing three or four beautifully framed family pictures. These are the photographs from the previous year produced during family photo sessions. There's always a nice close-up of the kids and probably a picture of everyone during our family vacation. Christmas is my annual deadline for adding to this collection of photographs, displayed on a large table in our living room. My wife has actually hinted that I slow down production a little because we're running out of space. She doesn't mean it, of course. She knows I'll never stop and hopes I won't. The pictures are too valuable. They give us pleasure all year long and everyone who comes into our home praises them. They are family treasures.

The method I've chosen for showing off my pictures is covering a tabletop with them. Some people cover walls. Some people fill albums. Some people fill wallets. It doesn't really make any difference what you do as long as you show off your efforts in some way.

What makes my method work for me is that it's simple. I arrange three or four family photo sessions a year. I take lots of pictures to get one great one. I do everything I can to produce great results. And at Christmas—my personal photo deadline for all kinds of family pictures—I spread the joy.

This system also enables me to relax. I don't feel the need to hit a triple every time I shoot a snapshot. I know I have good pictures in my computer and I can casually

BUT IF YOU

DON'T WANT TO

TALK ABOUT

YOUR BABY,

DON'T WEAR YOUR

PHOTOS TO A PARTY.

show it off

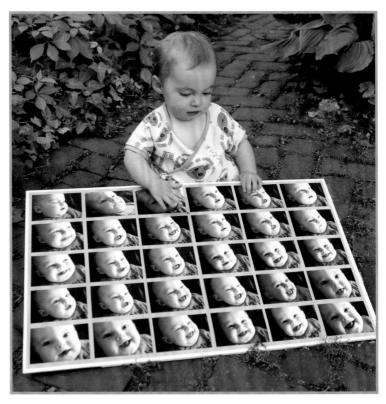

Making contact

With some minimal computer skills, you can combine many pictures into one photo and get poster-sized enlargements made at extremely modest prices—lots of pictures for the price of one.

Holiday Trimming

Here's a great idea from my friend Wells Jenkins: photographs as holiday decorations. It's easy to do on your own. Mount a favorite photograph of your baby on cardboard and decorate it with tinsel, glitter, ribbons, buttons, material—whatever—that you've glued on with a hot-glue gun or model glue. It's a fun project for kids to do and give as gifts. Of course, if you aren't in the do-it-yourself mood, you can have these made professionally. (www.wellsware.com)

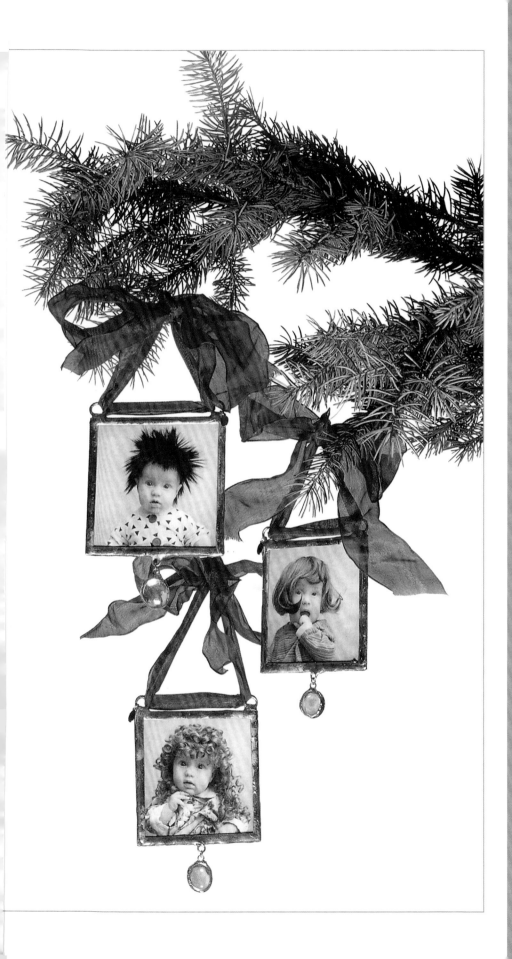

REAL REFRIGERATOR ART

Do this and you'll have the best refrigerator door in your baby group. It looks tricky, but it's really not that complicated. You will, however, need a lens that focuses quite close, probably about a foot. The goal is to produce one big photo mosaic that consists of sixteen small photos, like the pieces of a jigsaw puzzle. The finished product is perfect for a refrigerator door.

The first thing you need to do is focus your camera so that the viewfinder covers an area about 6 by 9 inches. Now imagine shooting 16 pictures at that distance in a grid pattern that's four pictures wide and four pictures deep. Picture that grid pattern laid over your baby when he's taking a nap; in other words, your baby is lying in the middle of the grid. Now start at one edge of the grid and shoot one row of four pictures. Then work your way back down the other row, like mowing the lawn. Don't worry if the edges don't line up perfectly. In fact, it's better of they don't. When you assemble the final photo, overlap the edges and randomly angle the prints.

I recommend doing this during your baby's nap because that may be the only time he will hold still for this activity. If you put the crib next to a window before the nap to take advantage of the wonderful light, you're going to have a great piece of kitchen art.

THEY *ARE* YOUR JEWELS!

Here's the traditional locket taken one step further. This photography as jewelry is beautiful. You can have necklaces, bracelets, brooches, and even cufflinks made from photos that are copied and reduced.

snap a few frames at family gatherings. Sometimes I don't even feel the need to shoot pictures at all. It's one of the photographer's least-talked-about skills: knowing when *not* to take pictures.

And it's a skill worth having. You can relax and enjoy your family as a participant and not as an observer. I have actually attended school plays camera-less. Just imagine: I sat there with all of the other teary-eyed parents, many of them with cameras, and savored the performance without feeling the compunction to take pictures. Our table-top full of moments preserved gives me comfort at the oddest moments.

There they sit on the table in our living room, staring at us from the past. We display them with love, sharing them daily with our friends and each other.

I notice them every time I'm in the room.

More ways to show off your photos!

BOTTOMS UP IN THE BATHROOM

No household with a baby should be without a naked-baby-bottom photo in the bathroom. The more ornate the frame it's in, the better. Very sweet and very funny. You will treasure this.

ELECTRONIC BABY

The relationship between your camera, your computer, and the photographs you shoot of your children is going to evolve faster than any writer of a how-to photo book can keep up with. But if you continue to search the internet for "photo sharing" I guarantee that your photography will make the people you love happy in ways none of us can imagine now.

IN YOUR POCKET

The photo wallet above holds three 3-by-5 prints and stands upright when opened. It's thin and light—a great gift for someone who travels a lot.

BABY'S OWN ALBUM

Baby photos for babies—they love them. Many copy shops can do lamination and spiral binding for you. A simple photo album works, but when the pictures are laminated they've got the added advantage of being completely drool-proof. There are all kinds of games you can play with this. Where is Anna's nose? Where is Anna's mouth? Which picture shows a smile? How many fingers can you find in this picture? The list is endless.

There are many similarities between making beautiful photographs and making beautiful music. One of the most important is that regardless of how much you may want to produce great art when you get behind the camera or sit down at the piano, practice and natural ability—more than raw will—are probably going to determine success.

I know that some of you won't understand the importance of finding the right light or don't want to be bothered with it—it's just not worth it to you—and that's fine. If the only thing you've learned when you walk away from this book is that you need to get really close when you photograph your baby, it will all be worth it. Your baby photographs, and just about everything else you shoot, will be better for it.

Then again, there are those of you who have taken to what I've presented in this book like Van Cliburn to Chopin. The simple ideas I've shared probably strike you as good, solid common sense and you're ready for more.

If you have some natural photographic talent and really exercise your visual muscles when it comes to lighting or composition, for example, you will give some pros a run for their money.

Included in this section are:

• Tips to help you set up a home studio, along with some of the tools you'll need.

• Simple techniques to use and mistakes to avoid that professionals take for granted. These "photography basics"—knowing when to use a telephoto lens and tripod, composing a photograph, and manipulating photographs on your computer—provide a solid foundation that gives their photographs a professional look.

• A few thoughts about how the rules of still photography apply to video. (They don't.) Here's a friendly boost up the photographic ladder. I hope you enjoy the view.

UP TO

TRYING NEW

CHALLENGES?

READ THIS

SECTION.

a little advanced

This is the same technology that is used to photograph bullets bursting balloons. It can certainly stop a baby rattle in mid-flight. It doesn't matter if you understand this concept. Why it works is not important. What it accomplishes is.

Any problems you've ever had that are caused by shaking the camera or a moving subject are virtually eliminated.

So doesn't the flash that's built in to your camera stop action, too?

Yes, it does, but it's visually unpleasing. With the home studio I've described here, and that's what it is, you get the advantages of beautiful natural light and high-tech professional equipment. It's the best of both worlds. And the whole setup is portable, so you can produce the light of Rembrandt anywhere you want.

The folks at your local photography store will be happy to help you set up a home studio and teach you how to use it. The results are nothing less than stunning. If you want to shoot high-quality baby portraits that your spouse will love you for, this is the way to go.

2. THE TELEPHOTO LENS

When I was in high school, I wanted a telephoto lens so badly I could taste it. I fantasized about shooting great sports pictures, capturing images of animals in the wild, and, I admit it, being the object of female worship. Very few of my fantasies—okay, none—came true, but when I finally got my telephoto lens I learned a valuable lesson.

The main function of telephoto lenses is not to bring objects closer.

The most useful thing a telephoto lens does is to change the way a picture looks. For one thing, you can throw a distracting background out of focus. When your baby's face is sharp and everything else is blurred, it gives a much more dramatic look to the picture. The emphasis is on what's important: your baby.

It also changes what photographers call "perspective." When you use a telephoto lens, the background appears to be much closer to

...photo lens puts a distracting background out of focus. In one picture (photo left) *the ...era was 4 feet away from the girl. In the other* (photo right) *a telephoto lens was used ...the camera was 15 feet away.*

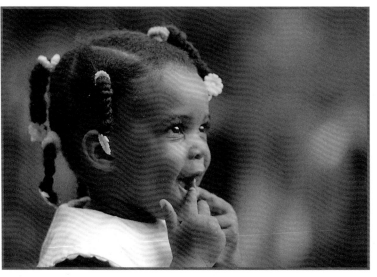

Her head is the same size in both pictures, but the backgrounds are different. The telephoto lens was not used to bring the subject closer but to eliminate the background—a very smart use of the lens.

...subject than it really is. This can be very useful as an ...rnative to your normal lens when you're composing ...r picture. The same scene will be dramatically ...rent through the two lenses.

...ost amateur cameras now have some kind of ...n lens. Zooming your camera in will produce ...ffect of a moderate telephoto lens. You ...need big fancy sports photographer ...ment to take advantage of this effect.

3. TRIPODS

...any types of photography, ...s are indispensable—people ...lots of time talking about sharp lenses, ...on't worry enough about having a good ...l. So I know I'm on thin ice discourag- ...y amateur from using one, but the fact ...t tripods are not very baby-photography friendly.

Here's what happens. You put your camera on a tripod and frame up a nice shot of your baby. She starts to move out of the frame. Then you're stuck with loosening the tripod, repositioning the camera, and locking the tripod down again. By the time you go through this drill, she's moved again and you're back to zero.

Baby photography is much too fluid for you to be anchored down with a tripod. I'm certainly not saying that there is no place for a tripod in your photography, but I am saying that there are times when it's okay not to use one, and photographing babies is certainly one of them.

4. COMPOSITION

There are photographers who would argue that you cannot teach photographic composition—you either have the requisite artist's eye or you don't. On the highest levels I know that's true, but amateurs make one basic and, I believe, understandable compositional mistake that is very easily remedied.

Thi...
for ta...
when...
amate...
irresi...
smac...

I ca...
high ...
perfe...
the w...

If I...
the fr...

So ...

Pho...
tool ...
assert...

Same si...
head de...
the pictu...
boy off...
more ...
become...
says so...
subject...

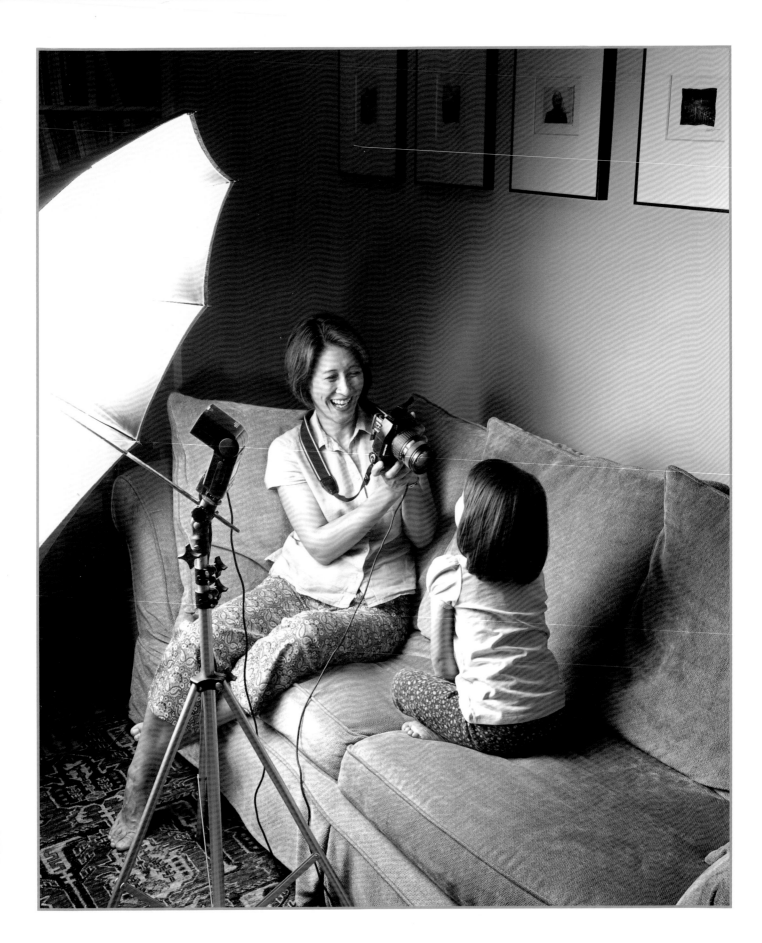

FIVE ADVANCED IDEAS

1. Setting up the home studio

Amateurs are often impressed, and perhaps intimated, by the quality of a professional's photographs. They assume that professionals use high-quality cameras, which is true, and that only high-quality cameras produce high-quality pictures, which is not true. The lenses on most point-and-shoots produce incredibly sharp images. In the twenty-first century, the discussion of whether a lens is sharp or not is almost silly. Modern technology has given us wonderful, inexpensive optics.

So why do professional photographs look so much better than the average amateur photograph?

When amateurs react to professional quality, I really think they're reacting to the fact that (and I know some of you are not going to like this) professionals use flash equipment. Considering that I have spent a large portion of this book telling you to turn off your flash, I apologize for the apparent contradiction. Amateurs use flashes, too. So how could a professional's flash produce higher-quality pictures than an amateur's? Let me explain.

The difference between a professional's flash and your flash is where it's located. Yours is built in to the camera—not just a bad place for a light, but the worst place. Practically every time you use it you are doomed to produce a photograph with that cold, heartless light I talked about in "Turn Off That Flash."

A professional's flash is often away from the camera, with the light hitting the subject from the side. When the light is coming from a different direction than the camera—and, aesthetically speaking, any direction is better than from the camera—you suddenly have a lighting effect that is producing shadows and highlights. One side of your baby's face is darker than the other. Things start to look beautiful and dramatic; it's Rembrandt light.

Professionals also use many different attachments on their flashes that soften the harsh light of a direct flash. They spend a lot of time trying to reproduce the very simple light of an open window. The good news is that the amateur photo market has given us lights and attachments whose results are every bit as good as professional equipment.

What you need to do is get your hands on the equipment that's seen in this photograph (right). There's a light stand, an umbrella reflector, and a portable flash that's wired into the camera. The total cost of all this equipment is around $400. There is some hassle involved; you have to set it up when you want to use it, and please understand that this is not possible with all cameras. You need a camera with a "hot shoe" on top; most single-lens reflex cameras have them, and a few point-and-shoots do as well. But if you can make this work with your camera, you're in for a treat.

Here's how it works. The flash is pointed into the umbrella. The light bounces out of the umbrella and lands on the subject. The quality of light this produces is nearly identical to the soft light of a window or door. But in one regard it is different, and even superior. Because it is a burst of light and not a continual source of light, like a regular light bulb or the sun, any movement in the photograph is frozen. *(continued on back of this fold-out)*

mistake is related to the use of the photographic term "shoot" ing pictures. Many cameras today are point-and-shoots, and you shoot something you need to take aim. And that's what rs do when they shoot photographs—they take aim. It's totally ible for inexperienced photographers to put their subjects dab in the middle of the frame and, well, pull the trigger.

see it in their photography. Unfortunately, they are hitting a ercentage of bull's eyes. Most of their pictures have the subject ly centered. I think there's a reason they call it *dead center*. In rld of artistic composition, hitting a bull's eye is deadly.

old you to never, ever put your subject right in the middle of ne, I would be overstating my case—and doing you a favor. on't. Ever.

ography is one big contradiction. The camera is a delicate self-expression, and yet to use it sensitively requires some ve behavior. You need to aggressively push the button, invade your subject's personal space, move in closer and closer and closer, and then, when you're finally close enough, compose lovingly tender images in which your subject isn't perfectly centered.

5. BLACK-AND-WHITE PHOTOGRAPHY

I love black-and-white photography. When I was fifteen and obsessed with photography, I dreamt in black-and-white.

An old high-school friend visited me recently, and when I showed him *Naked Babies*, the all-black-and-white book of baby pictures I coauthored with Anna Quindlen, his first comment was, "Aren't you ever going to buy a camera that takes color pictures?"

Well, all of my cameras take color pictures, and I love color photography, too. But my heart still belongs in the darkroom where the whites and blacks and grays appeared out of the red mist.

But it's a color world, full of color images. Today's amateur photo industry is built around color photography. And one of the great advantages of digital photography is that you can make the decision to convert a picture to black-and-white after it's been taken in color.

I haven't even attempted to address photo manipulation computer programs in this book (Photoshop being the prime example). Most cameras now come with some kind of software that works with your camera. Most of them are decent, but I highly recommend spending the roughly $100 for Adobe Photoshop Elements. It's the younger sibling of Photoshop and has many of the best features. With it you can take your photographs to the next level. If you're intimidated by the idea of working with your photographs, I say relax and give it a try. It's so satisfying and really, really fun.

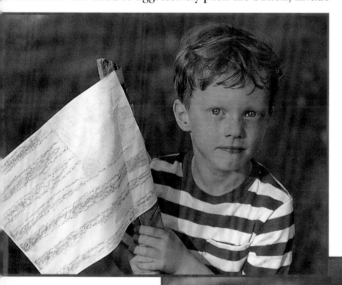

ation, two different feelings. With the d center in the frame (photo right) e lacks impact. With the flag and the enter (photo above) the picture is mpelling. The flag and the boy quals and the visual relationship ething about the boy. An off-center almost always more interesting.

What about video?

Does the core advice I've given—get closer, take more pictures, and turn off your flash—apply to video cameras? It depends on your definition of "apply." In other words, not really. Do the opposite of everything you've done with your point-and-shoot, and you'll be fine. Here's what I mean.

1. Get Closer? Don't.

Amateurs are zoom-happy. It's just too much fun to push that zoom button and watch through the viewfinder as you float into a tight face shot—hey, it was one of the reasons you bought the camera. But unlike your point-and-shoot still camera, home video cameras don't produce beautiful images. They do a wonderful job of recording information, however, and you will get more information in the picture with a wider shot.

Video is a great way to record what your baby's room looked like, for example. A two-minute walk through your house with the camera running, recording every room, will supply you with waves of memories in years to come. Of course, close-ups of faces are wonderful, but amateurs get stuck there and are slow to zoom back out. Think in terms of photographing action: blowing out birthday candles, playing with the new puppy, recording first steps taken. Still cameras have trouble competing with this.

2. Shoot more film? Bad idea.

Turning the camera on and letting it roll until you become bored with the situation is a big mistake. If you thought it was boring the first time, wait until you've gathered your friends and family to watch it again. It can be downright painful. Think in terms of short, simple shots. If the situation you're videotaping is a little low on action—for example, your baby is playing with the stuffed animals your parents brought—make sure you pan the camera around the room and get nice reaction shots of Grandma and Grandpa watching the baby play. Then turn the camera off.

3. Turn off your flash. Light isn't a concern.

I know, I know, video cameras don't have flashes. But because I've tried to raise your awareness of appropriate light, I need to tell you not to worry about lighting conditions when shooting video. With still photography the idea is to make beautiful images, and for that you need beautiful light. It's not a consideration with video; the quality of the light is not all that important. With today's amazing video technology, virtually whatever light there is will be good enough. The one situation in which video cameras don't do well is with a subject in a dark area with a bright background—for example, a person silhouetted against a window with light shining in. The camera can't quite figure out how to expose properly. Beyond that, don't worry about light.

It seems unrealistic to present the work of a professional baby photographer as the standard of quality and expect amateurs to meet the challenge. And when the professional cheats, as I did, it's downright unjust.

Not all of the pictures I shot for this book were taken using the natural-light/no-flash method I prescribe. For some photos I used professional lighting equipment that produced results few amateurs could ever replicate in their homes.

All pictures in this section, however, were taken by people who played by the rules. They are not professional photographers—they're just parents interested in producing something more than a mundane snapshot. I asked each of them to shoot a minimum of one hundred pictures in one photo session. They used the core advice in this book—get closer, push the button a lot, and turn off your flash—and applied it to the pictures they took of their own babies.

They describe what they learned in their own words, but in the conversations I had with them afterward they all emphasized one point: Shooting one hundred photographs of their babies in thirty minutes was not just fun, it was also liberating because there was no consideration of expense. The luxury of making mistakes is a wonderful gift you can and should give yourself.

I thought it would be nice to show you the faces of the photographers and their subjects, so I asked each of them to come to my studio for a portrait. The passage of time reveals that where babies once were, there are now little boys and girls.

The photos remain.

Is it possible to improve the quality of your photographs in a single photo session? Of course I believe it is, but let the viewer judge. Regardless of what you or I think, there wasn't a single mom or dad involved in this project who didn't love the photographs they took.

IF MY

NEIGHBOR

CAN DO IT,

YOU CAN DO IT.

AND MY

NEIGHBOR DID IT.

yes, it's possible

EVERYTHING YOU NEED TO KNOW ABOUT DIGITAL . . . REALLY. EVERYTHING.

Of course, it's *not quite* everything, but here are a few things to keep in mind.

A digital camera is a computer with a lens. Like any other computer, it can be friend or foe. Yes, there's a bit of a learning curve, but it's worth it.

Get comfortable with a photo-processing program. *Photoshop* is the grand-daddy of all of them and still the best, but probably more than you need—or want—to spend. *Photoshop Elements* is perfect for amateurs and it's affordable. It's also the most fun you'll ever have on a computer.

Almost all digital cameras are too complicated. What are all of those settings anyway? Simplify your life. Master the important ones first. Learn how to use the following in your sleep:

- turn your flash off and on
- make pictures brighter and darker (exposure compensation)
- use the auto-focus

There is no need to shoot the largest file size if you're only going to email pictures and make small prints (4 by 6 inches). Experiment to find what's right for you and your camera. Smaller files mean you can shoot more pictures faster. And they're easier to manage and store on your computer.

Turn the ISO up to 400 or 800. Your camera will be much more forgiving of squirmy babies and squirmy photographers. If your pictures look noisy (digital grain) turn the ISO down. But if your pictures look good to you, and they probably will, they're, well, good.

Electronic cameras are electronic junk without electricity. You need two batteries. Sorry.

And two media cards isn't a bad idea either. Sorry.

Investigate using RAW files. All digital photos need to be processed by a computer. If you don't shoot RAW, the camera will do it for you and the camera is not always right. If you do shoot RAW, *you* adjust the picture to your taste on your computer. And shooting RAW covers up lots of technical errors. It sounds complicated—it's not.

When you put your camera away, leave it on auto-exposure, auto-focus, and turn the ISO up. When your baby decides to be super-cute, all you have to do is turn the camera on and push the button.

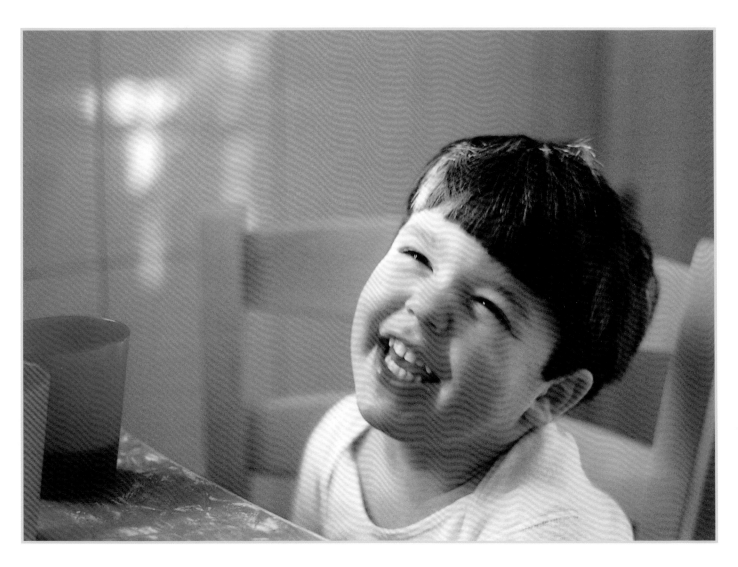

"This photograph captured a spontaneous moment at the kitchen table where the natural light was beautiful. I was much closer to Elias than I normally am when I take pictures. We just sort of made a game out of it—I got in closer, and he laughed. This is my favorite picture of Elias. I keep it over my computer."

MATTHEW BARTHOLOMEW, FATHER OF ELIAS

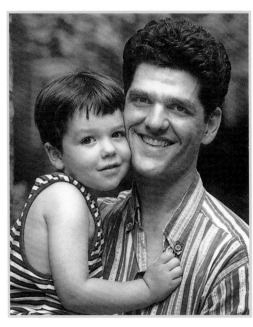

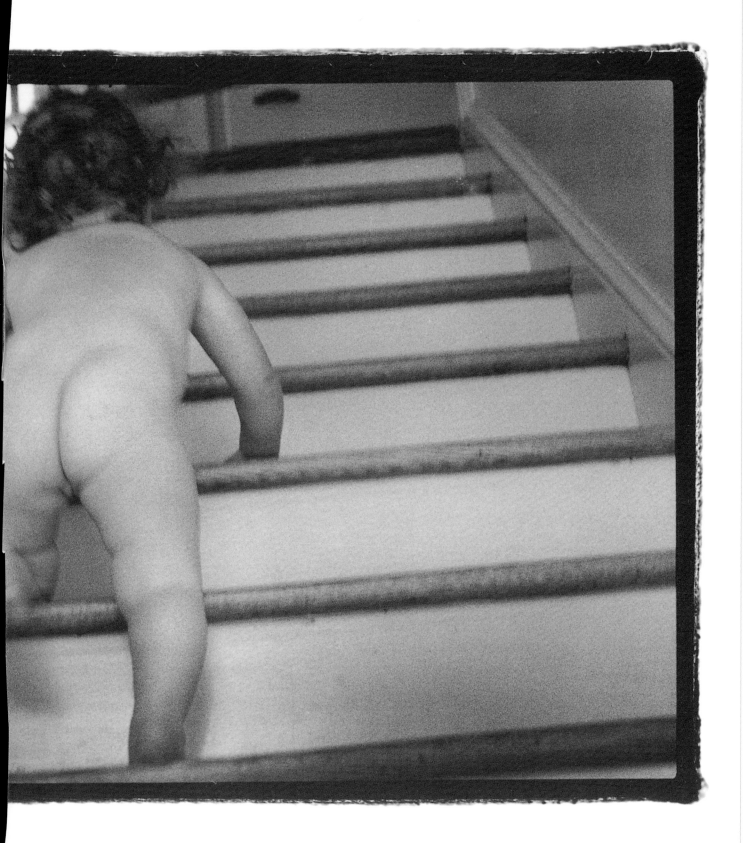

"I shot 150 pictures in about thirty minutes—
something I've never considered doing before. I
think it's important to try to take the pictures when
just you and your baby are home. It was very relax-
ing and we just sort of played together. I got several
pictures that I love. When I thought the photo
session was over, I let Sophie climb up the stairs.
It looked so cute that I just kept shooting. I love
the black-and-white. It looks so timeless."

LORI WEINROTT,
MOTHER OF SOPHIE

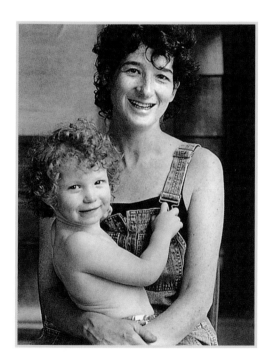

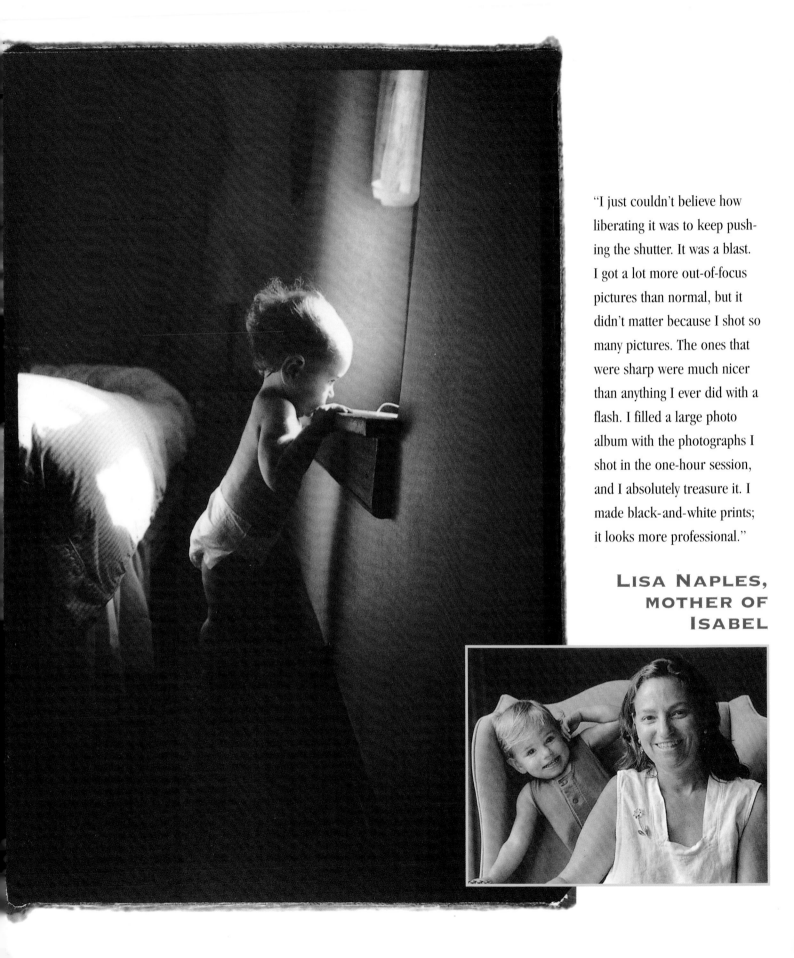

"I just couldn't believe how liberating it was to keep pushing the shutter. It was a blast. I got a lot more out-of-focus pictures than normal, but it didn't matter because I shot so many pictures. The ones that were sharp were much nicer than anything I ever did with a flash. I filled a large photo album with the photographs I shot in the one-hour session, and I absolutely treasure it. I made black-and-white prints; it looks more professional."

LISA NAPLES, MOTHER OF ISABEL

"When my daughter was born, I put the ISO at 1200 at the hospital and left it there. I had to deal with different types of light—including fluorescent and daylight—the high ISO made it much easier. A high ISO allows you to get a higher percentage of sharp pictures when you get this close. This is one of my favorite pictures of Allison."

FRANK GARBER, FATHER OF ALLISON

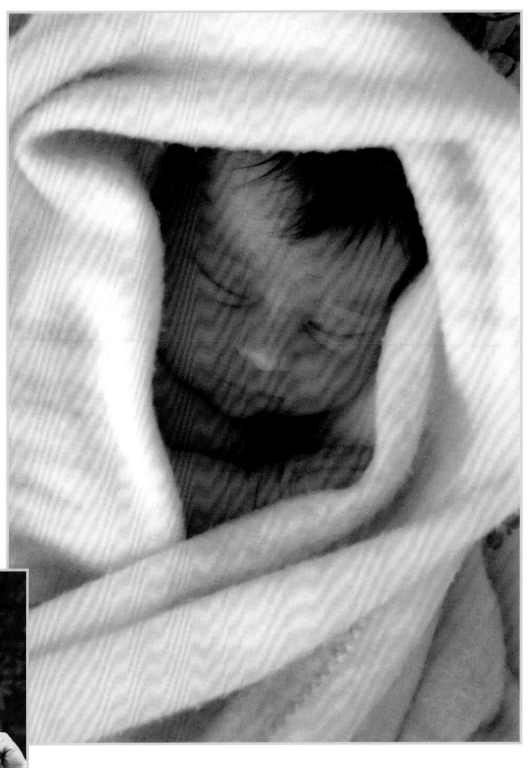

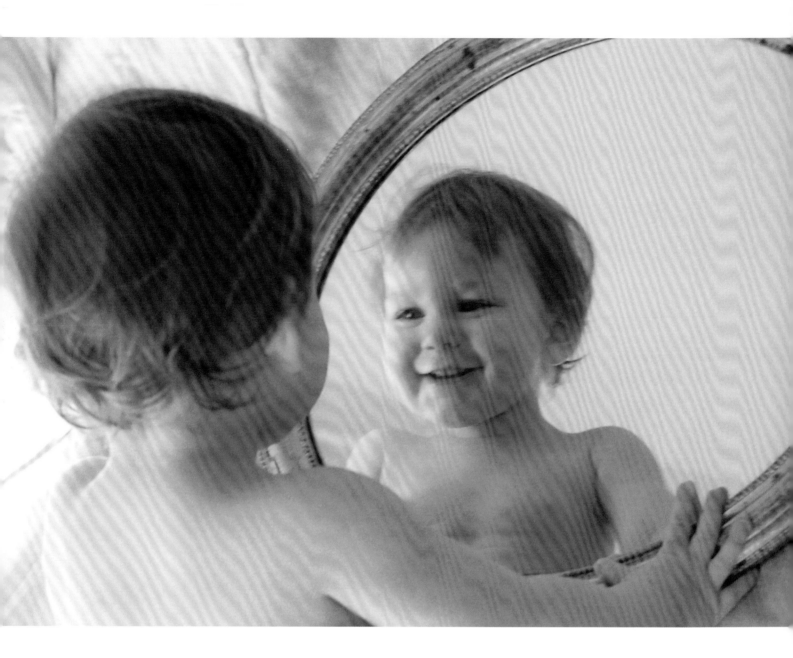

"The big thing was taking lots of pictures and not treating every picture as though it had to work. I could take chances, and it paid off. Some of my favorite pictures were just lucky, but I guess that's what professionals hope will happen to them when they shoot lots of pictures—that they get lucky. The result was that I had a lot of fun and got some lovely pictures of my daughter at a beautiful time in her life."

CHRIS SIMPSON, FATHER OF MIMI

"I shot my photographs under a shade tree. The light was soft and beautiful, and I kept thinking in black-and-white. I got in so close that I cut the top of Kyle's head off in this picture. I remember reading somewhere that you should never do that, but I really liked it. I used this picture as a Christmas card, and I'm still getting compliments on it."

DAVID GRIFFIN, FATHER OF KYLE

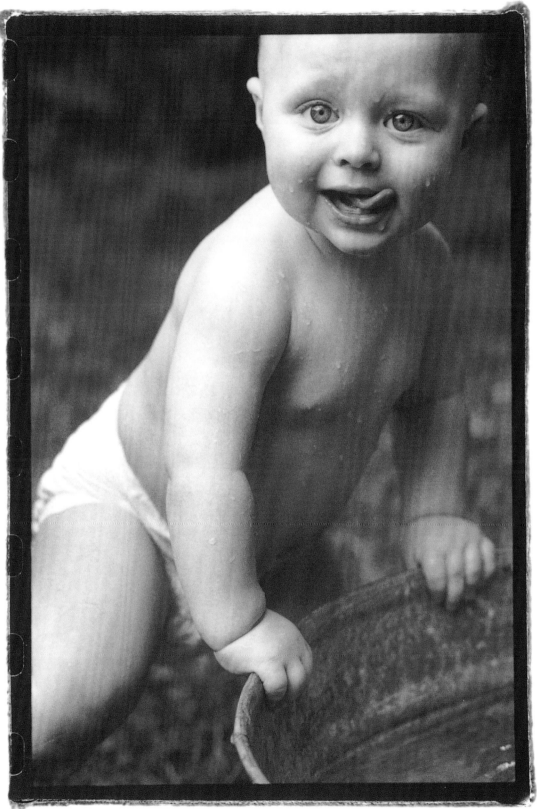

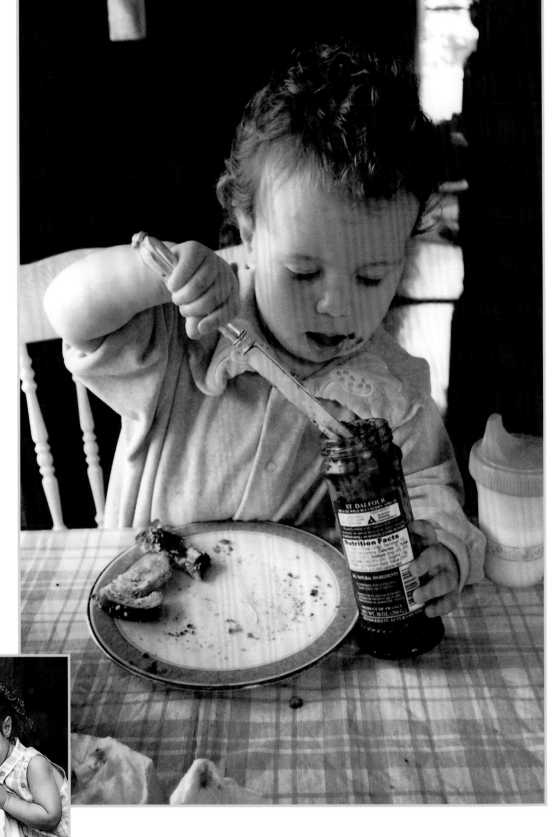

"It's become obvious to me that taking lots of pictures is pretty basic to getting good pictures. Now I usually wait for a good picture-taking situation and then shoot twenty or more pictures. The overall quality of my pictures is so much better when I do this, and it's a much more exciting approach to photography. My interest in photography in general has really increased since I started doing this."

KEVIN MONKO, FATHER OF OLIVIA

Create something
your baby's babies
will treasure forever.

NICK KELSH
nick@kelsh.com

THANK YOU

*I would like to thank the following children for allowing me
to photograph them and, in the process, for brightening my life.*

Elias Bartholomew, Spencer and Tommy Barton, Julia Boldt, Marques Bura, Emily and Thomas Cairns, Sam Conant, Michael Falduto, Allison Garber, Gina Gibson, Zahikaira Green, Kyle Griffin, Alexis Guido, Sophie Holman, Grant Richard James, Caroline Jones, Kadita Koita, Thomas Lennon, Jarod Adnan Louie, Benjamin Amadeus D. Malit, Isabella T.R. Martin, Chance Allen Melo, Miximillian Miller, W. Tate Miller, Olivia Monko, Evan Morgan, Isabel Naples, Paula Quon, Andrew Restrepo, Alyssa Kendall Ruehle, Isabel Schmidt, Claire Schmidt, Emma Schmidt, Lilah Jean Schrading, Eugene A. Shekhtman, Everette M. Simon, Mimi Simpson, Andres Esteban Soloalvarro, Siena Stroh, Lance Wertz, Asante Glen Williams, Michael Henry Williamson, and Samira Wilson.

*Special thanks to Marta Hallett, Liz Sullivan,
Tricia Levi, and Karen Engelmann.
You were wonderful to work with.*

*The following people also contributed their time,
knowledge, and patience. My gratitude to them all.*

Dick Bell, Ken Bookman, Lia Calhoun, Sharon Chantiles, John Conant, Marguerite Del Guidice, Geneva Dorman, Vernon Dorman, Barbara Guido, Wells Jenkins, Denise Jones, Bob Martin, Kevin Monko, Nell Moyer, Gabe Piser, Susan Romn, Court and Colleen Schmidt, John Sivello and everyone at Penguin Photo, Richard Smith, the staff of Kelsh Wilson Design, Inc., Professional Color in Philadelphia, and Rachel Cabrera and the rest of the staff at S Editions and Stewart, Tabori & Chang.

METRIC CONVERSION
centimeters = feet x 30.5

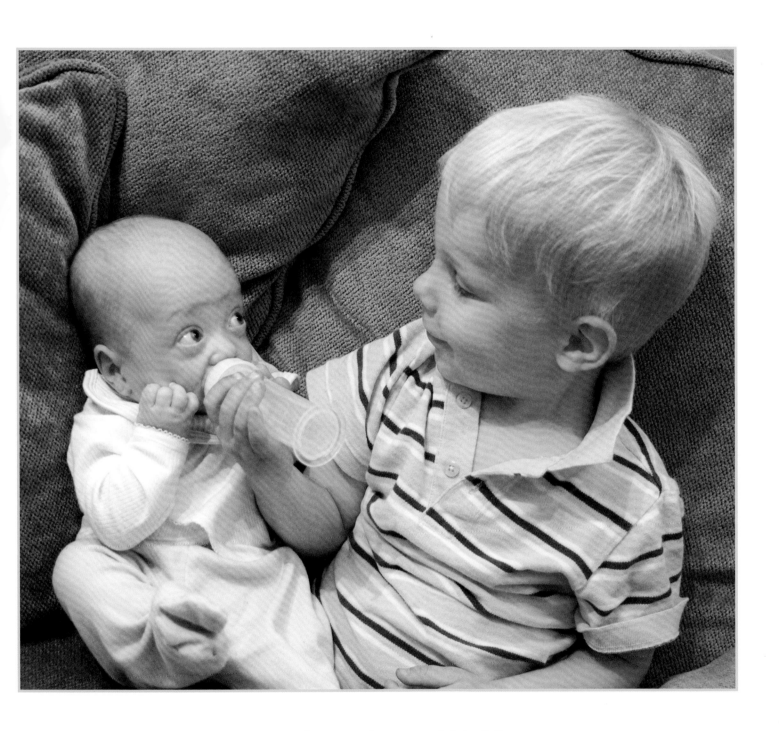

For Alexander and Teddy

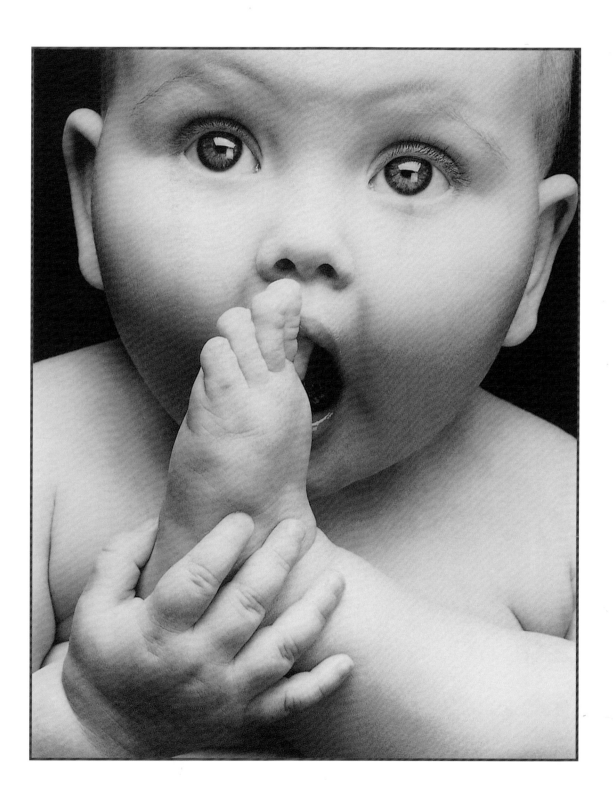